Francis Frith's
Around Ludlow

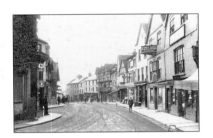

Photographic Memories

Francis Frith's
Around Ludlow

Dorothy Nicolle

Paperback edition published in the United Kingdom in 2000 by
Frith Book Company Ltd

British Library Cataloguing in Publication Data

Francis Frith's
Around Ludlow

Dorothy Nicolle

ISBN 1-85937-176-0

Frith Book Company Ltd
Frith's Barn, Teffont,
Salisbury, Wiltshire SP3 5QP
Tel: +44 (0) 1722 716 376
Email: info@frithbook.co.uk
www.frithbook.co.uk

Printed and bound in Great Britain

Front Cover: Broad Street and the Angel Hotel 1936 87393

Contents

Francis Frith: *Victorian Pioneer*

FRANCIS FRITH, Victorian founder of the world-famous photographic archive, was a complex and multitudinous man. A devout Quaker and a highly successful Victorian businessman, he was both philosophic by nature and pioneering in outlook.

By 1855 Francis Frith had already established a wholesale grocery business in Liverpool, and sold it for the astonishing sum of £200,000, which is the equivalent today of over £15,000,000. Now a multi-millionaire, he was able to indulge his passion for travel. As a child he had pored over travel books written by early explorers, and his fancy and imagination had been stirred by family holidays to the sublime mountain regions of Wales and Scotland. 'What a land of spirit-stirring and enriching scenes and places!' he had written. He was to return to these scenes of grandeur in later years to 'recapture the thousands of vivid and tender memories', but with a different purpose. Now in his thirties, and captivated by the new science of photography, Frith set out on a series of pioneering journeys to the Nile regions that occupied him from 1856 until 1860.

Intrigue and Adventure

He took with him on his travels a specially-designed wicker carriage that acted as both dark-room and sleeping chamber. These far-flung journeys were packed with intrigue and adventure. In his life story, written when he was sixty-three, Frith tells of being held captive by bandits, and of fighting 'an awful midnight battle to the very point of surrender with a deadly pack of hungry, wild dogs'. Sporting flowing Arab costume, Frith arrived at Akaba by camel seventy years before Lawrence, where he encountered 'desert princes and rival sheikhs, blazing with jewel-hilted swords'.

During these extraordinary adventures he was assiduously exploring the desert regions bordering the Nile and patiently recording the antiquities and peoples with his camera. He was the first photographer to venture beyond the sixth cataract. Africa was still the mysterious 'Dark Continent', and Stanley and Livingstone's historic meeting was a decade into the future. The conditions for picture taking confound belief. He laboured for hours in his wicker dark-room in the sweltering heat of the desert, while the volatile chemicals fizzed dangerously in their trays. Often he was forced to work in remote tombs and caves where conditions were cooler. Back in London he exhibited his photographs and was

'rapturously cheered' by members of the Royal Society. His reputation as a photographer was made overnight. An eminent modern historian has likened their impact on the population of the time to that on our own generation of the first photographs taken on the surface of the moon.

Venture of a Life-Time

Characteristically, Frith quickly spotted the opportunity to create a new business as a specialist publisher of photographs. He lived in an era of immense and sometimes violent change. For the poor in the early part of Victoria's reign work was a drudge and the hours long, and people had precious little free time to enjoy themselves. Most had no transport other than a cart or gig at their disposal, and had not travelled far beyond the

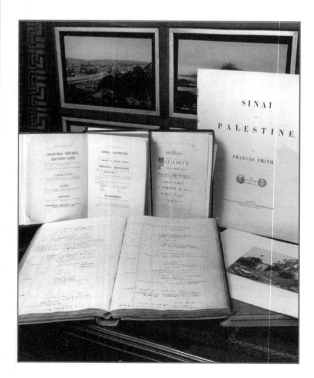

boundaries of their own town or village. However, by the 1870s, the railways had threaded their way across the country, and Bank Holidays and half-day Saturdays had been made obligatory by Act of Parliament. All of a sudden the ordinary working man and his family were able to enjoy days out and see a little more of the world.

With characteristic business acumen, Francis Frith foresaw that these new tourists would enjoy having souvenirs to commemorate their days out. In 1860 he married Mary Ann Rosling and set out with the intention of photographing every city, town and village in Britain. For the next thirty years he travelled the country by train and by pony and trap, producing fine photographs of seaside resorts and beauty spots that were keenly bought by millions of Victorians. These prints were painstakingly pasted into family albums and pored over during the dark nights of winter, rekindling precious memories of summer excursions.

The Rise of Frith & Co

Frith's studio was soon supplying retail shops all over the country. To meet the demand he gathered about him a small team of photographers, and published the work of independent artist-photographers of the calibre of Roger Fenton and Francis Bedford. In order to gain some understanding of the scale of Frith's business one only has to look at the catalogue issued by Frith & Co in 1886: it runs to some 670 pages, listing not only many thousands of views of the British Isles but also many photographs of most European countries, and China, Japan, the USA and

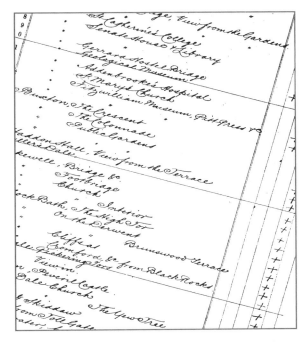

Canada – note the sample page shown above from the hand-written *Frith & Co* ledgers detailing pictures taken. By 1890 Frith had created the greatest specialist photographic publishing company in the world, with over 2,000 outlets – more than the combined number that Boots and W H Smith have today! The picture on the right shows the *Frith & Co* display board at Ingleton in the Yorkshire Dales. Beautifully constructed with mahogany frame and gilt inserts, it could display up to a dozen local scenes.

Postcard Bonanza

The ever-popular holiday postcard we know today took many years to develop. In 1870 the Post Office issued the first plain cards, with a pre-printed stamp on one face. In 1894 they allowed other publishers' cards to be sent through the mail with an attached adhesive halfpenny stamp. Demand grew rapidly, and in 1895 a new size of postcard was permitted called the court card, but there was little room for illustration. In 1899, a year after Frith's death, a new card measuring 5.5 x 3.5 inches became the standard format, but it was not until 1902 that the divided back came into being, with address and message on one face and a full-size illustration on the other. *Frith & Co* were in the vanguard of postcard development, and Frith's sons Eustace and Cyril continued their father's monumental task, expanding the number of views offered to the public and recording more and more places in Britain, as the coasts and countryside were opened up to mass travel.

Francis Frith died in 1898 at his villa in Cannes, his great project still growing. The archive he created continued in business for another seventy years. By 1970 it contained over a third of a million pictures of 7,000 cities, towns and villages. The massive photographic record Frith has left to us stands as a living monument to a special and very remarkable man.

Frith's Archive: *A Unique Legacy*

FRANCIS FRITH'S legacy to us today is of immense significance and value, for the magnificent archive of evocative photographs he created provides a unique record of change in 7,000 cities, towns and villages throughout Britain over a century and more. Frith and his fellow studio photographers revisited locations many times down the years to update their views, compiling for us an enthralling and colourful pageant of British life and character.

We tend to think of Frith's sepia views of Britain as nostalgic, for most of us use them to conjure up memories of places in our own lives with which we have family associations. It often makes us forget that to Francis Frith they were records of daily life as it was actually being lived in the cities, towns and villages of his day. The Victorian age was one of great and often bewildering change for ordinary people, and though the pictures evoke an impression of slower times, life was as busy and hectic as it is today.

We are fortunate that Frith was a photographer of the people, dedicated to recording the minutiae of everyday life. For it is this sheer wealth of visual data, the painstaking chronicle of changes in dress, transport, street layouts, buildings, housing, engineering and landscape that captivates us so much today. His remarkable images offer us a powerful link with the past and with the lives of our ancestors.

Today's Technology

Computers have now made it possible for Frith's many thousands of images to be accessed almost instantly. In the Frith archive today, each photograph is carefully 'digitised' then stored on a CD Rom. Frith archivists can locate a single photograph amongst thousands within seconds. Views can be catalogued and sorted under a variety of categories of place and content to the immediate benefit of researchers.

Inexpensive reference prints can be created for them at the touch of a mouse button, and a wide range of books and other printed materials assembled and published for a wider, more general readership - in the next twelve months over a hundred Frith local history titles will be published! The day-to-day workings of the archive are very different from how they were in Francis Frith's time: imagine the herculean task of sorting through eleven tons of glass negatives as Frith had to do to locate a particular

See Frith at www. frithbook.co.uk

sequence of pictures! Yet the archive still prides itself on maintaining the same high standards of excellence laid down by Francis Frith, including the painstaking cataloguing and indexing of every view.

It is curious to reflect on how the internet now allows researchers in America and elsewhere greater instant access to the archive than Frith himself ever enjoyed. Many thousands of individual views can be called up on screen within seconds on one of the Frith internet sites, enabling people living continents away to revisit the streets of their ancestral home town, or view places in Britain where they have enjoyed holidays. Many overseas researchers welcome the chance to view special theme selections, such as transport, sports, costume and ancient monuments.

We are certain that Francis Frith would have heartily approved of these modern developments in imaging techniques, for he himself was always working at the very limits of Victorian photographic technology.

The Value of the Archive Today

Because of the benefits brought by the computer, Frith's images are increasingly studied by social historians, by researchers into genealogy and ancestry, by architects, town planners, and by teachers and schoolchildren involved in local history projects.

In addition, the archive offers every one of us an opportunity to examine the places where we and our families have lived and worked down the years. Highly successful in Frith's own era, the archive is now, a century and more on, entering a new phase of popularity.

The Past in Tune with the Future

Historians consider the Francis Frith Collection to be of prime national importance. It is the only archive of its kind remaining in private ownership and has been valued at a million pounds. However, this figure is now rapidly increasing as digital technology enables more and more people around the world to enjoy its benefits.

Francis Frith's archive is now housed in an historic timber barn in the beautiful village of Teffont in Wiltshire. Its founder would not recognize the archive office as it is today. In place of the many thousands of dusty boxes containing glass plate negatives and an all-pervading odour of photographic chemicals, there are now ranks of computer screens. He would be amazed to watch his images travelling round the world at unimaginable speeds through network and internet lines.

The archive's future is both bright and exciting. Francis Frith, with his unshakeable belief in making photographs available to the greatest number of people, would undoubtedly approve of what is being done today with his lifetime's work. His photographs, depicting our shared past, are now bringing pleasure and enlightenment to millions around the world a century and more after his death.

Around Ludlow - *An Introduction*

A few years ago an article on Ludlow in the Sunday Times newspaper asked: 'is this the best town in England?' Ask anyone who lives in the town today what they think, and chances are that they will say 'yes, without a doubt.'

And yet, when you think of its beginnings it is rather strange that this should be so. Ludlow was a planned town foisted on a local populace who, at the time, preferred to live elsewhere. The town, or rather its castle, was established by the newly-conquering Normans at the end of the 1000s, and history was to show that they had certainly chosen their site well.

But let us go back even further in time. Although there may not have been a settlement here in 1066, the hilltop site had been the focus of an important routeway and possible meeting place since time immemorial. Ludlow sits beside the River Teme. Just below the town there was a point where the river was easily forded; some thousand years before the Normans, the Romans had built a road using this ford.

But even the Romans were not the first people passing through and using this route. We know that when the church of St Lawrence was extended in the late 1100s an old burial mound, possibly of the Bronze Age, was destroyed to make room for the new extension. So even if people were not living and settling on this hill some four thousand years ago, they certainly thought the site was impressive enough to bury a chieftain there, overlooking what had probably been his territories during his lifetime.

And this brings us to the settlement's name,

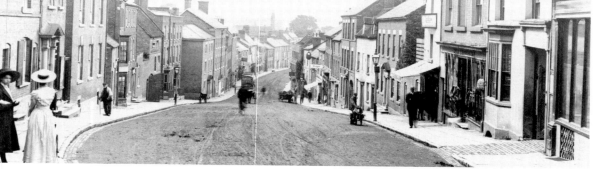

Ludlow. We do not know for certain what the name means, and a great deal of argument has arisen on this subject. Many people are convinced that the 'lud' refers to the 'loud' waters of the River Teme, which seems reasonable until you wonder about the 'low'. The Anglo-Saxon word 'low' usually refers to a burial mound (the one by the church, perhaps?) or a hill, but a 'loud hill' or 'loud burial mound' just does not make sense. Our language has changed a great deal over the past one thousand years, but an adjective has always been used to describe a noun and therefore surely the 'lud' must somehow be describing the 'low'.

So what does 'lud' mean? An alternative explanation is that 'lud' was a person's name. If this was the case, he may well have been a Saxon who once owned land in the area and had, in the years since his death, become associated in local folklore with the historically much earlier burial mound. Hence Lud's low. We will probably never know for sure what the name actually means.

But whatever it means, when the Norman conquerors of England chose this hilltop site for their castle they knew exactly what they were doing. It was some twenty years after the Conquest that the castle was built, probably by Roger Lacy whose family had come from Normandy with William I. The Lacy family held several castles in the region, but Ludlow was to become the most important. It was sited right at the end of the cliff and was surrounded on almost three sides by the River Teme; within a very short time, a settlement was established beside it with a market that brought traders from far and near.

The survival of the town was dependent on both the importance and power of the castle and on its own success as a market centre for local people. In this instance it compares well with Wigmore, a few miles away just over the border in Herefordshire. Like Ludlow, Wigmore castle sat beside an ancient routeway and soon had a settlement with a market associated with it. Yet Ludlow thrived and Wigmore died. It all comes to 'location, location, location' in the end. Ludlow and Wigmore were both of them part of a series of castles all along the Welsh borders, or Marches, as they have come to be known. It was a turbulent region that saw constant skirmishing, cattle-rustling and the like throughout medieval times.

Relative peace finally came to the area with the accession of the Tudors to the throne of England in 1485. This was to usher in a period of tremendous change for Ludlow. Wales had to be administered, but the court was based in Westminster, much too far away. It was therefore decided that the principality should be administered from Ludlow instead, and so, for the next two centuries or so, Ludlow became the 'capital' of Wales despite being in England.

Wales and the borders were under the administration of the Council in the Marches; from the beginning Ludlow's importance was

emphasised by the presence of King Henry VII's son, Prince Arthur, the Prince of Wales coming to live in the castle here with his bride, Catherine of Aragon. Prince Arthur was to die some months later, and although his body was taken for burial in the cathedral at Worcester, his heart was buried in St Lawrence's church in Ludlow.

In overall control of the Council in the Marches was a Lord President, answerable directly to the monarch. An early Lord President was Rowland Lee, Bishop of Coventry, whose law-making was to make 'all the thieves in Wales quake with fear'. For this was an essential part of Ludlow's role. Not only was Wales governed from Ludlow, but also it was here that court cases dealing with Welsh matters were held, and this alone was to bring the town great prosperity. I was once told (by someone of Welsh ancestry I might add) that 'the Welsh are a litigious race, and Ludlow profited immensely as a result'! This legal wealth can best be seen in the sheer exuberance of the decoration on what is now the Feathers Hotel, originally the house of a lawyer.

Where the court (both administrative and legal) led, so the gentility followed, and when the Council was abolished in 1689 they stayed. To this day Ludlow has about it the air of class and style with which it was imbued in the 1700s. In that period local landowners who could afford neither the time nor the money to go 'for the Season' to London came here instead. They built smart town houses in Ludlow, and before long Ludlow had become a centre for 'smart society'. An Assembly Room was built where balls were held. Walks were laid out at this time on the cliffs around the castle so that people could promenade in comfort. A racecourse was established just outside the town. All these, evidence of a former life of style and grandeur, still exist and are in use today.

It was not all fun and jollity for everyone, however. The town did have an industrial base too; one particular industry for which the town was well-known from the 18th century was the production of gloves. In fact, in the early 1800s over 700 people were employed in the industry, a huge number considering that the total population of the town at that time was in the region of 5,000 people. They were then producing some 365,000 pairs of gloves each year, some of which were exported as far afield as the United States.

Ludlow's importance as a social centre for the upper classes was to decline in Victorian times. This decline was largely due to the increase in improved communications, particularly with the coming of the railways, so that those whose social life had previously centred on Ludlow could now more easily travel further afield. The railway came to Ludlow in the 1850s; although it meant that socialites preferred to go elsewhere, it did at least bring about a revival in the town's fortunes as a market centre serving the rural community surrounding it.

In recent years, however, this rural community

has itself seen a sharp decline in its fortunes, and instead Ludlow has once again reclaimed its position as a centre for genteel living. People have recently rediscovered the town that John Betjeman described in 1943 as 'probably the loveliest town in England' and have started to move back in droves. This revival began in a very small way. In 1934 an anniversary production of John Milton's 'Comus' was performed here. The poet had written this work while living in Ludlow as Secretary to the Lord President of the time, and it had first been performed here, in the grounds of Ludlow Castle, exactly 300 years before. Further productions were made in the 1950s expressly to raise funds to restore St Lawrence's church, and these were so successful that in 1960 it was decided to run an annual Ludlow Festival.

Since then the Festival has grown in stature so that it now runs in June and July each year with numerous performances and exhibitions associated with arts of all kinds. Thus Ludlow is now recognised internationally as a centre of the fine arts - and not just for around two weeks of each year. The town is awash with antique shops and second-hand book shops. Its restaurants are acknowledged to be the best in the country outside London. This has had an unfortunate side result, in that house prices locally have spiralled upwards; Ludlow has become a fashion-leader and trend-setter amongst those seeking the smartest places in which to live.

Ludlow has been variously described as 'the perfect small country town', 'the most appealing of English hill towns', and even as 'one of Europe's most beautiful towns'. It is indeed all of these, and yet it still seems to keep a sense of proportion. Delightful though the town is for the visitor in terms of its architecture and history, it is still very much a small and friendly place where one feels immediately at home.

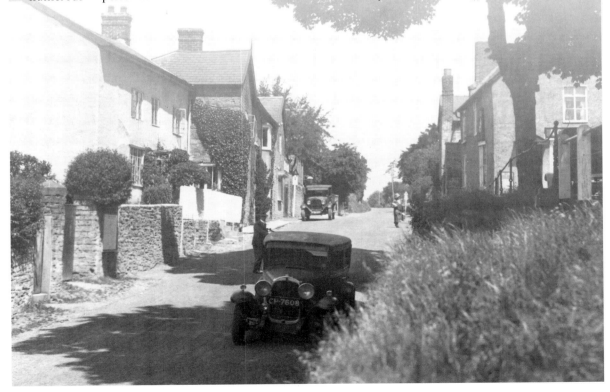

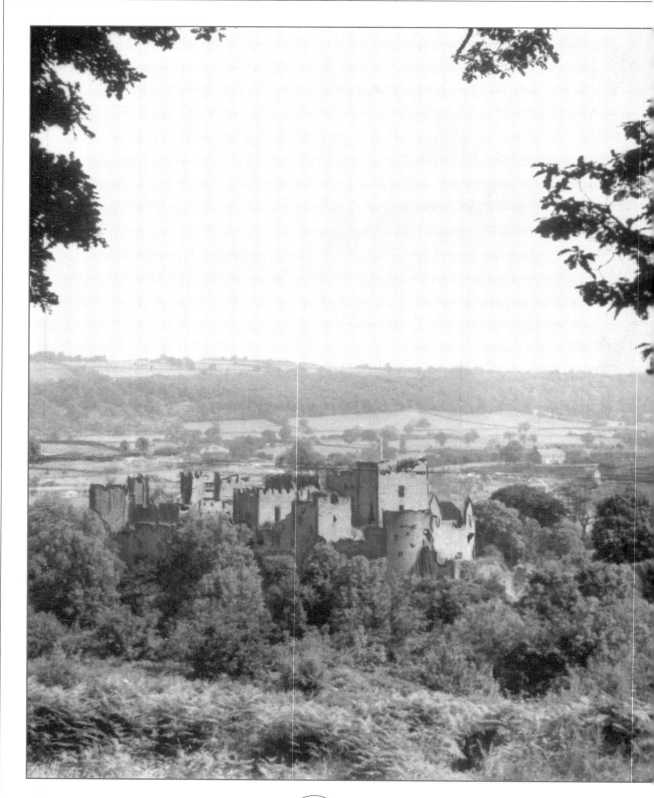

The Castle

The Castle from Whitcliffe Common c1960
L111097
This is easily one of my favourite views in the whole county of Shropshire; it overlooks the town of Ludlow, which is dominated by the ruins of its castle and the tower of St Lawrence's church.

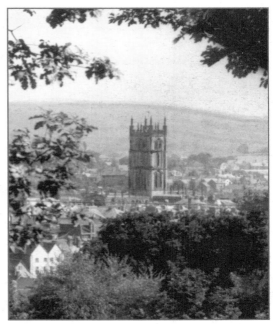

**Extract from: The Castle
from Whitcliffe Common c1960** L111097

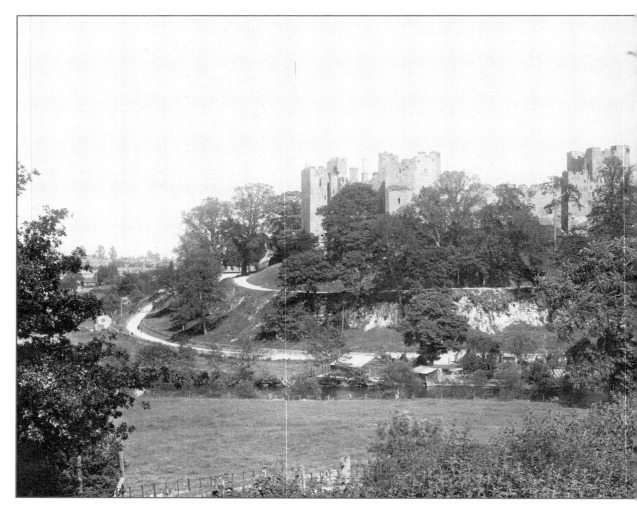

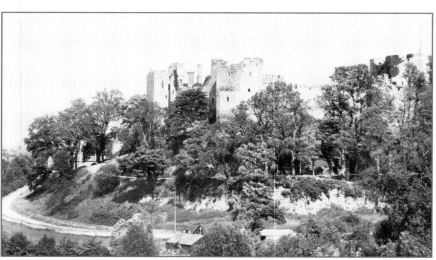

◀ **The Castle from the Quarry 1896** 38149
Notice the paths around the castle – walks were first laid out here in the 18th century for the gentry to enjoy. At the time it was a very popular pastime to promenade along such walks, meet friends, gossip and show off your finery in this way.

**◄ The Castle
from the North-West
1923** 73774
The first castle on this site probably dates from around the 1080s. When the Normans conquered England they rapidly built many wooden motte and bailey castles from which they could control the land. This one was different – it was a stone castle from the very beginning.

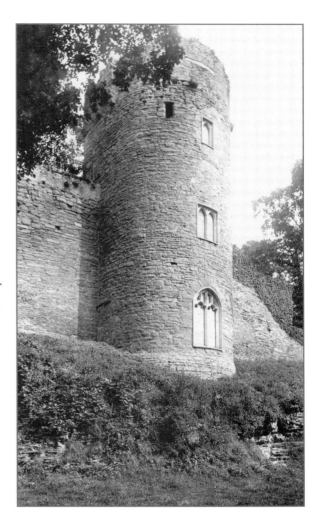

**The Mortimer ►
Tower 1892** 30810
The Mortimers were a very powerful family in the Marches (the Welsh borders) from the 13th to the 15th centuries. The most famous member of the family was probably Roger Mortimer, who was instrumental in the murder of Edward II and was later executed. Ludlow was one of several castles the family held.

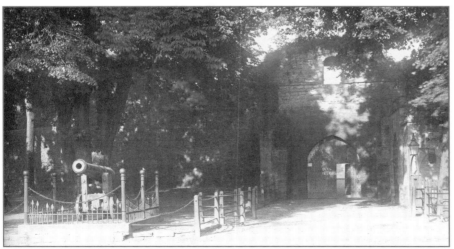

**◄ The Castle Entrance
1892** 30809
The entrance to the castle is still guarded, over one hundred years later, by this cannon. In the summer guided tours of the town are held at weekends, and these always meet by the cannon outside the castle entrance.

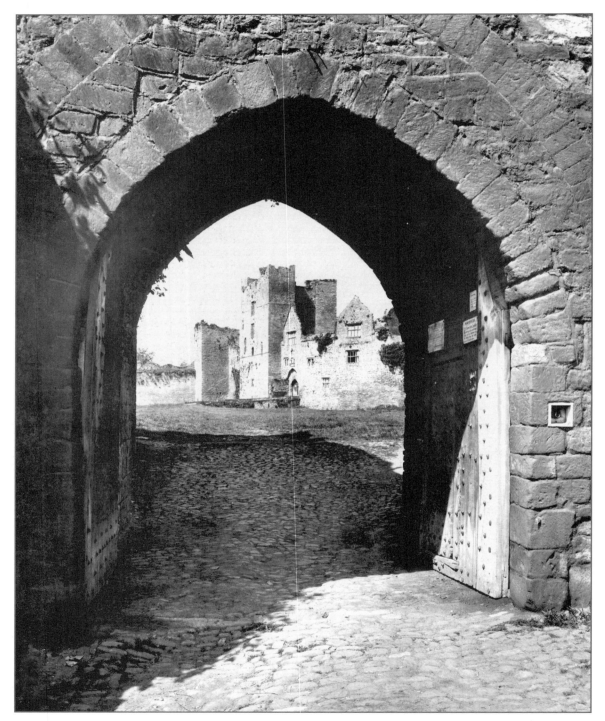

The Castle Gateway 1925 76894
Since 1811 the castle has been owned by the Earls of Powis, and has always been opened to the public. Here one of the signs on the doorway states that admission costs 1/- (one shilling), or 5p in today's money.

The Castle Entrance 1892

Costs, however, had risen considerably from thirty years beforehand. The white notice on this doorway leading into the main part of the castle states that admission was 6d (2½ of today's pennies) in 1892.

The Castle Interior 1892

This is a lovely view of the main part of the castle. The original castle is the massive keep in the centre, with later buildings added on the right. The shrubs below the castle have since been removed. They are growing in the dry moat, which originally served as a quarry providing the stone with which to build the castle.

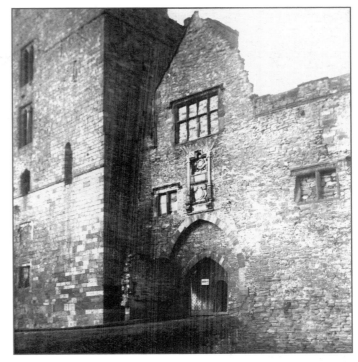

The Castle Entrance 1892 30810A

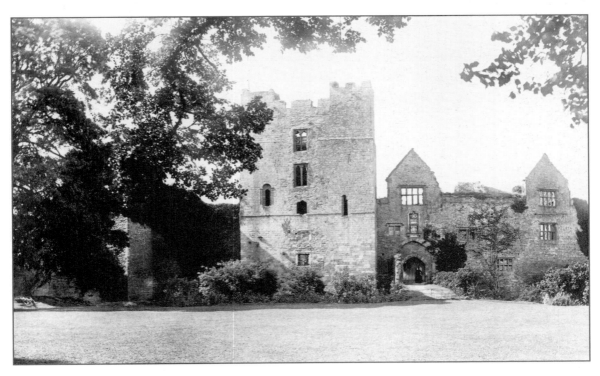

The Castle Interior 1892 30814

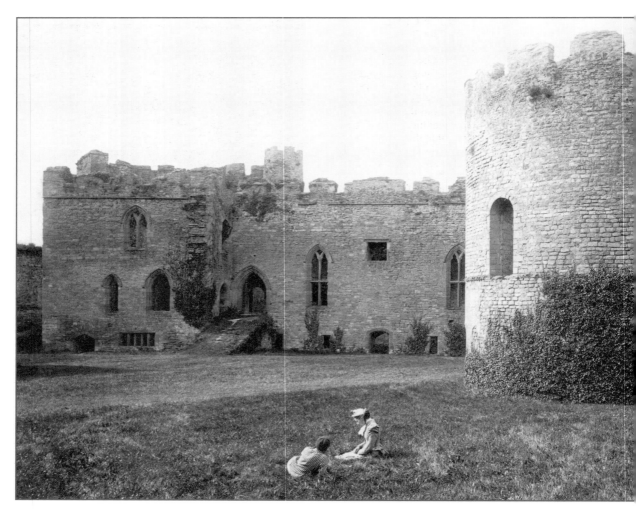

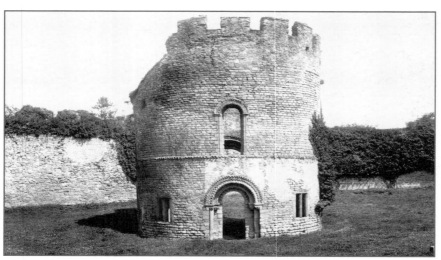

◄ **The Castle
The Norman Chapel
1911** 63197
This round building is a stunning survival. It is all that remains of the round chapel of St Mary Magdalene. Round chapels such as this are extremely rare; they were usually associated with the Knights Templar (as was the case here), a movement that began in England in 1128.

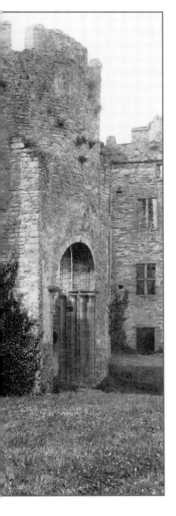

The Castle
The Round Chapel
1892 30818

What a romantic setting for a young, courting(?) couple! The Great Hall dates from the 13th century; it was here that the two Princes, Edward and Richard, lived in the late 1400s. They then went to live in the Tower of London – and mysteriously disappeared from history.

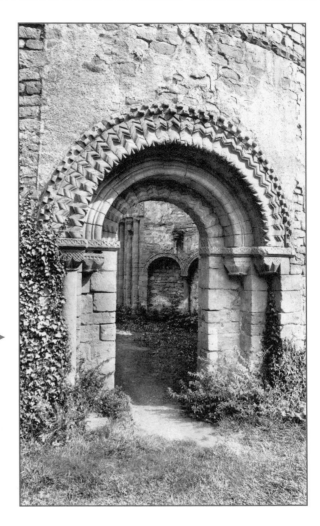

The Castle ▶
The Chapel Door
1892 30820

The part of the round chapel that still exists is the nave, and this is its west door. The original Norman chancel was demolished and replaced in the 16th century, and its replacement has itself since been destroyed.

◀ **The Castle**
the Doorway to the Keep 1903 50730

A castle's keep was its strongest part, yet even here our ancestors still felt that decorative detail was important. Thank goodness there have always been people who think that way.

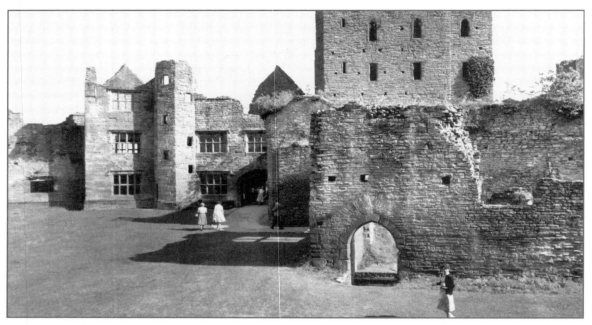

The Keep and the Judge's Quarters c1960 L111107
Indeed, in the late 1700s the government wanted to demolish what little was then left of the old castle. The architect who costed the project deliberately undervalued the potential worth of the materials on site and overvalued the expense of carrying out the work of demolition, and so, fortunately, managed to save it!

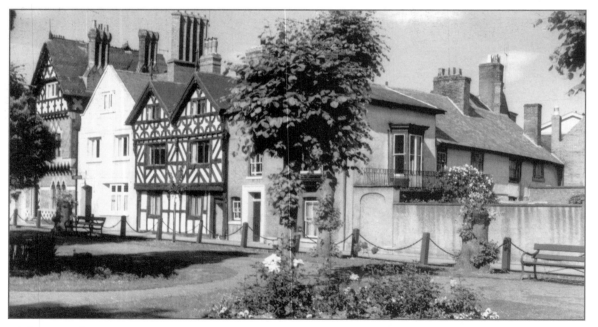

Dinham c1960 L111123
Dinham is the name given to that area of Ludlow immediately to the south of the castle. It is thought by some that this would have been the site of the earliest Norman settlement on the hilltop. The open flower-bedded area abuts the castle wall and probably covers an early ditch or moat.

The Town

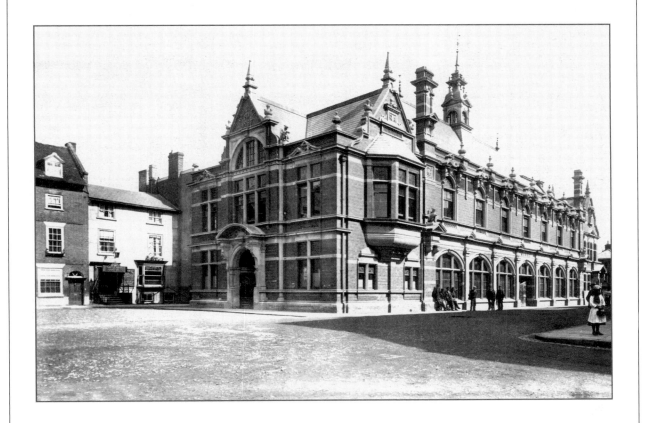

The Market Hall 1892 30828
The market hall was demolished in 1986. Built in 1887, it was
described by Nikolaus Pevsner as 'Ludlow's bad luck … There is
nothing that could be said in favour of its fiery brick or useless
Elizabethan detail'. One could hardly be more condemning.

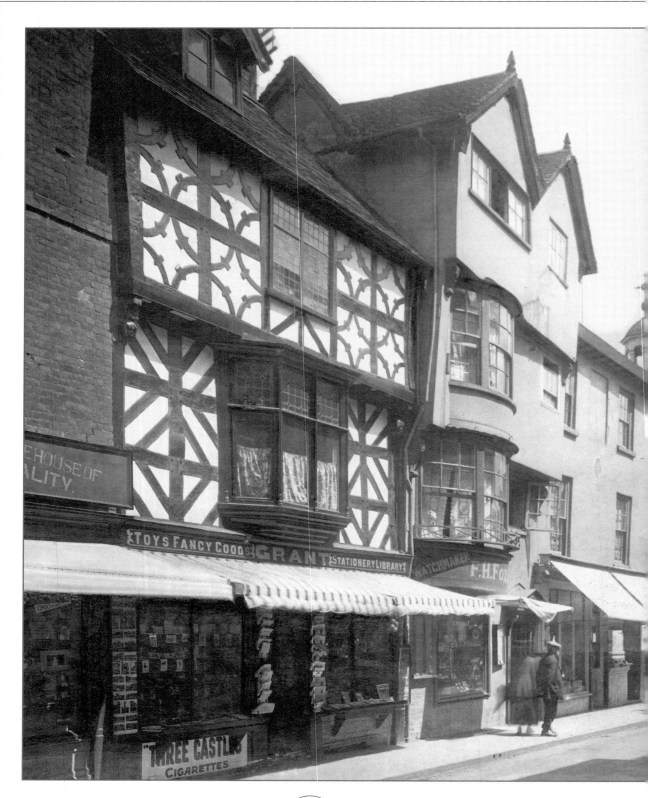

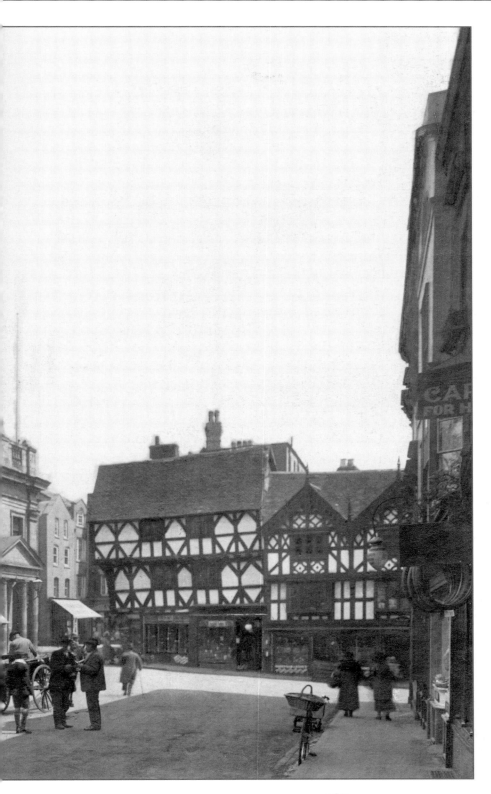

High Street 1923
73775
Notice the shop on the left selling toys and fancy goods. There is a display board full of postcards on the wall beside the window – including some Francis Frith postcards, perhaps?

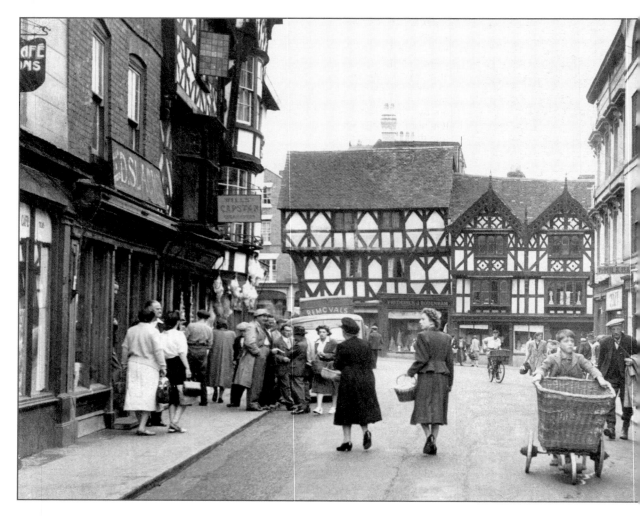

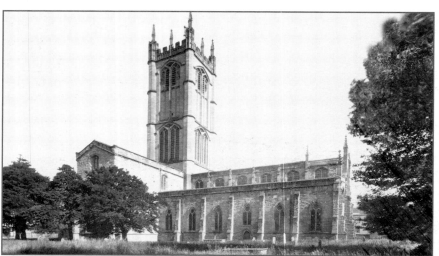

◄ **St Lawrence's Church 1923** 73787
Today the gravestones and tombs have all been removed. In fact, in 1812 it was felt that the graveyard was overcrowded, and an alternative was then established in 1824 beside Corve Street. Today we often cannot seem to decide whether we like formal, tidy churchyards (as this now is) or wild overgrown ones.

◄ High Street c1950
L111057

One tends to think of delivery boys with large wicker baskets as having disappeared by this time, but there are two in this picture. It is not that long ago that the photograph was taken. Do they still live in the town?

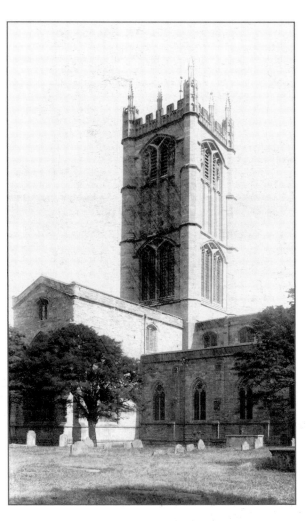

The Church Tower ►
1896 38153

The Normans may have settled around their castle, but the first settlement on the hilltop was probably near the site of the present church. Part of it sits on the site of a prehistoric burial mound that was demolished when the church was extended at the end of the 12th century.

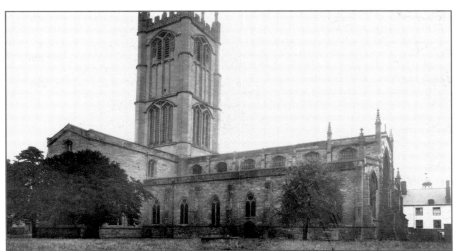

◄ St Lawrence's Parish Church c1955 L111033

The tree on the right has since been replaced with cherry trees on either side of the west door. These were planted to commemorate AE Housman, the poet most famous for his volume of poems 'A Shropshire Lad' - one poem begins 'Loveliest of trees, the cherry now Is hung with bloom along the bough'. He died in 1936, and his ashes are buried in the church wall just to the right of this tree.

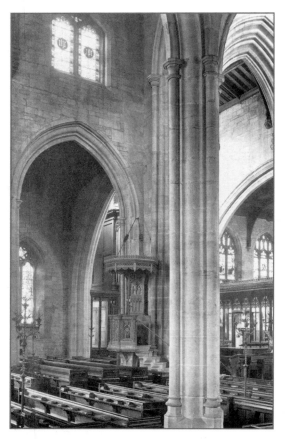

St Lawrence's Church 1911 63210

St Lawrence's is Shropshire's largest parish church, and is sometimes described as 'the cathedral of the Marches'. Here it is easy to understand why. The church is also extremely rich in stained glass, including a beautiful medieval Jesse window, showing the family tree of Jesus.

St Lawrence's Church ▶ The Reredos 1892

30841

The reredos is a largely Victorian restoration, and is certainly 'marvelous fayre' – a description once made about the entire church. The tomb on the left is that of Sir Robert Townshend and was built in 1581. I particularly like the detail, the Bible in his hand and the way his feet rest on a deer.

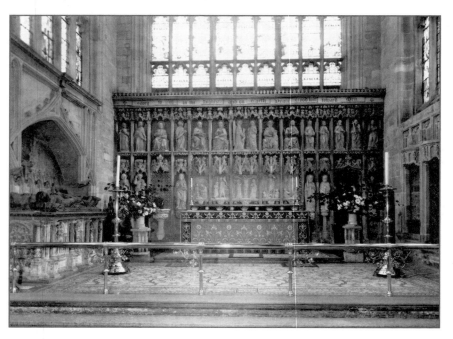

◀ St Lawrence's Church the High Altar c1960

L111113

Magnificent though the reredos, stained glass and tombs undoubtedly are, I feel that the church's greatest treasures are its carved misericords. These are a total delight; indeed some of them, depicting scenes of medieval life, are in fact very funny.

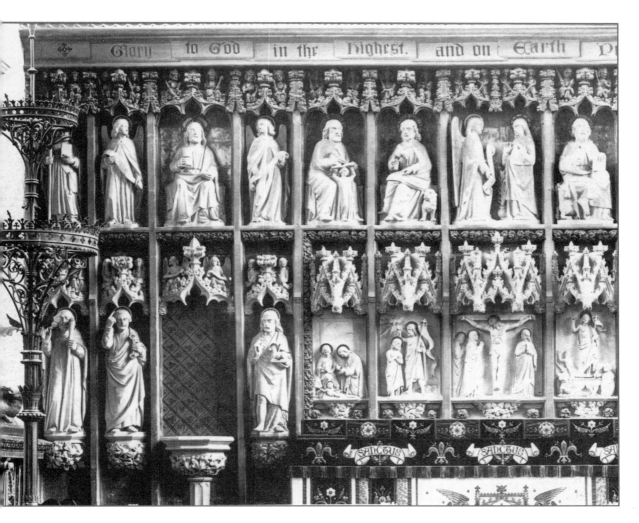

Glory to God in the Highest, and on Earth P[...]

SANCTUS SANCTUS SA[...]

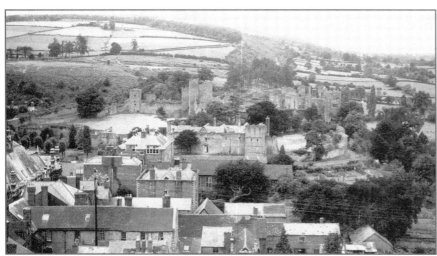

◀ **The Castle from the Church Tower c1955**

L111042

The view from the church tower is superb in all directions. Here we are looking towards the castle. The building on the extreme left is the town hall, which was later demolished. The area in which it stood is now used regularly as an open market.

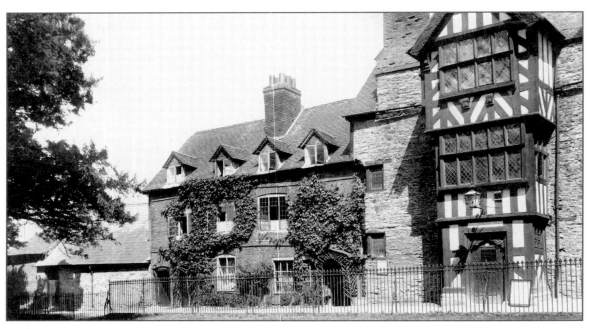

The Reader's House 1911 63196

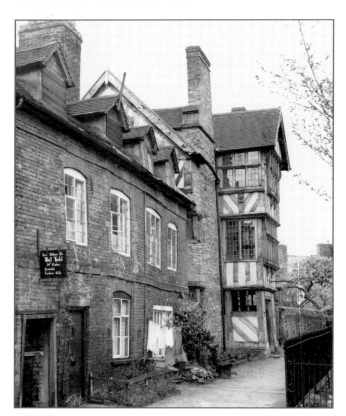

The Reader's House 1911
From the 1500s a Reader was appointed to
take on the duties of a present-day curate
for the church, and in the 18th century the
Reader occupied this building. The porch,
with its wonderfully decorative carving,
dates from 1616, but much of the building
is quite a bit older than that.

The Reader's House c1965
The sign on the wall indicates a right of way
through to the courtyard of the Bull Hotel.
The Bull is probably Ludlow's oldest inn, and
comes complete with a recently discovered
priest's hole built into one of the
chimney breasts.

The Reader's House c1965 L111162

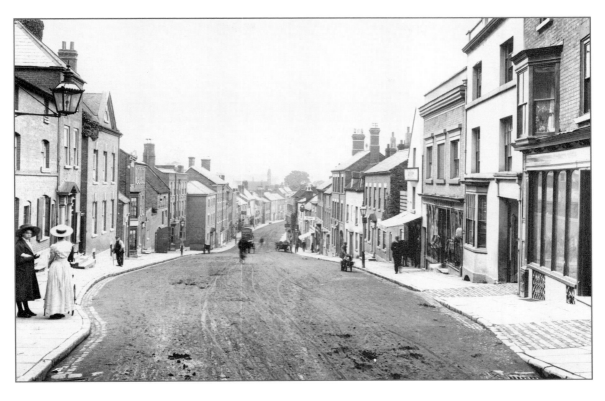

Corve Street 1910 62477
Corve Street leads north, and was the main road to
Shrewsbury. In fact, as a routeway Corve Street,
and Old Street into which it leads to the south, may
well have followed an old Roman, or even earlier,
route linking with a ford across the River Teme.

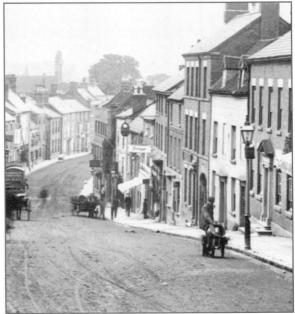

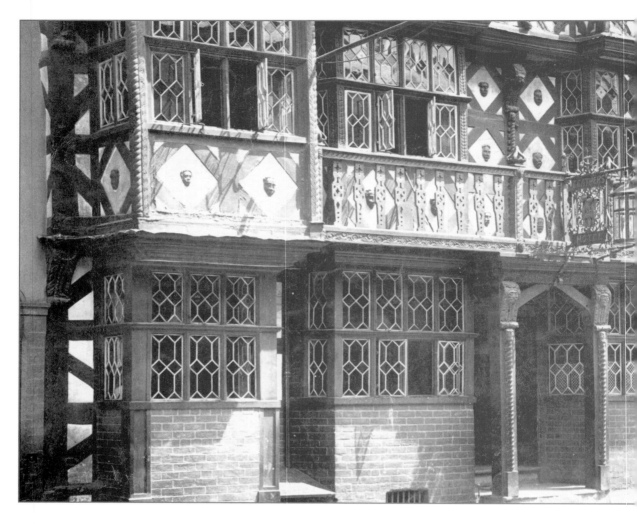

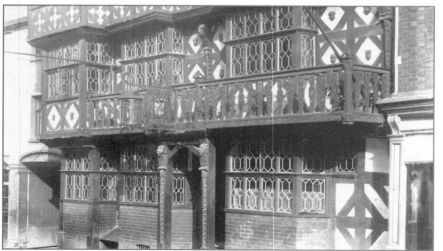

◄ **The Feathers Hotel 1903** 50725
The Feathers became an inn in around 1670; at one time the stables behind (today's car parks) had accommodation for one hundred horses.

The Feathers Hotel 1904 51651

The world-famous Feathers Hotel was built as a private house in the early 1600s by a lawyer, and no expense was spared. In a period when just about every fine building in the county was owned by a wool or cloth merchant, this house reminds us of the importance of the legal profession to the wealth of Ludlow.

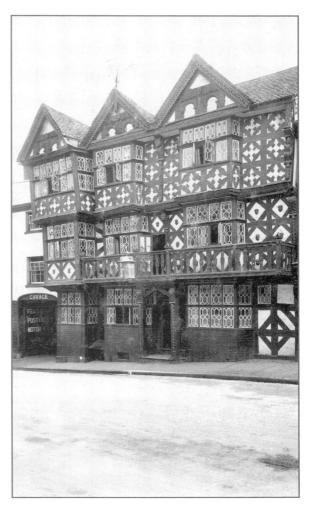

The Feathers Hotel ▶ 1925 76891

Today the decorative carving is much as it was when first built, with the exception of the balconies, which were added in the 19th century. The main room in the house is on the middle floor on the left of the building; it has a truly magnificent plaster ceiling.

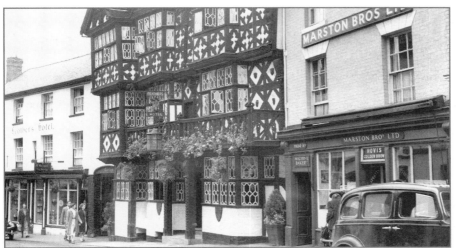

◀ The Feathers Hotel c1955 L111053

This is how the Feathers often looks today – festooned with summer hanging baskets full of flowers. Notice also the sign saying 'Machine Bakery' on the baker's shop to the right.

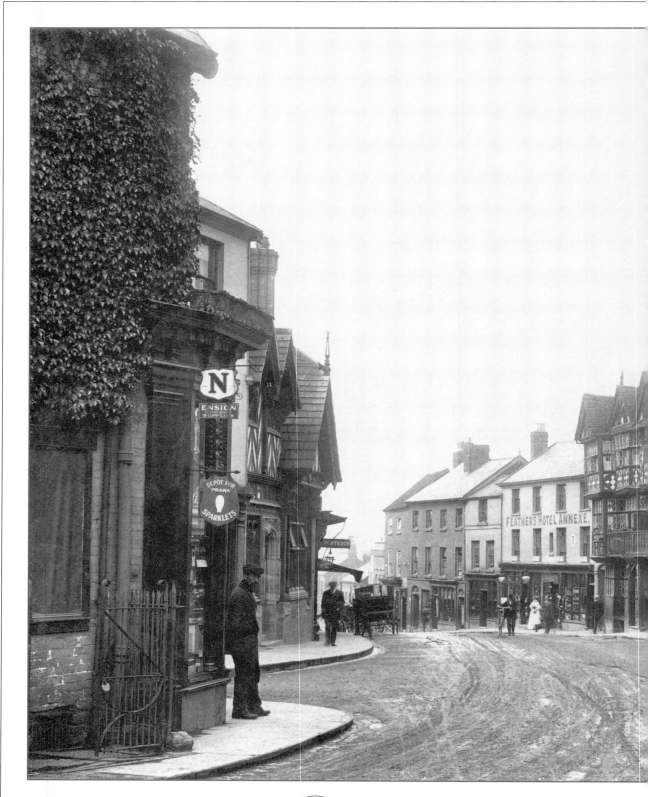

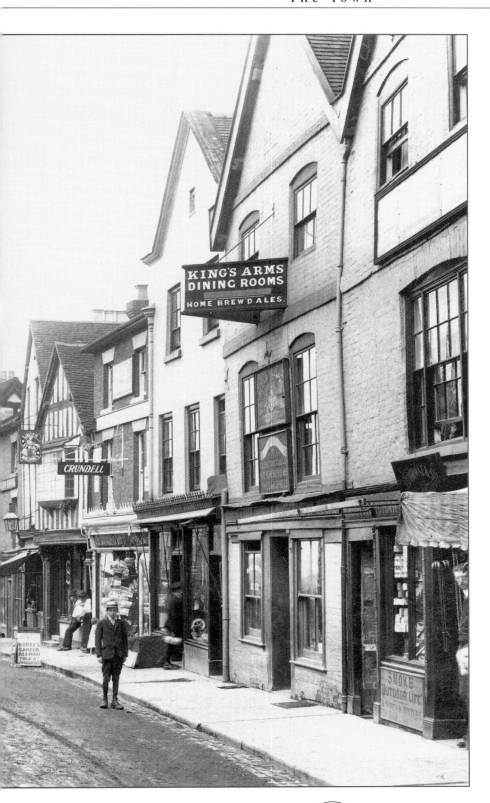

The Bull Ring 1910
62476
Racy stories have always sold newspapers. The news board on the side of the road is advertising the Daily Mail, with a story about a 'woman's career as man told at inquest'. One wonders what that was all about!

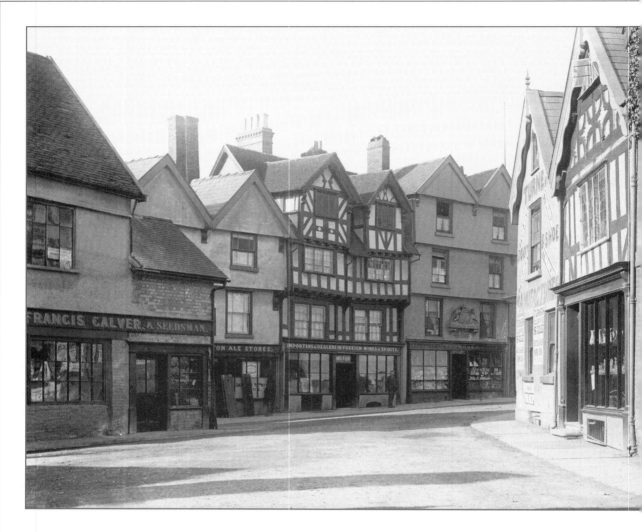

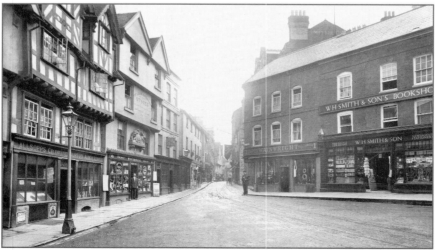

◀ **The Bull Ring 1910**
62475
Woodhouse, the Chemists, would appear to have its proprietor standing proudly by the door. He has a fine crest over the shop; notice, also, the sign on the floor above – it advertises the use of a darkroom 'free to customers'.

◀ The Bull Ring 1892

30831

This sequence of three photographs is fun to compare. All the buildings in this picture have since been stripped to their timber framing. Especially interesting is the shop on the left; it is now revealed as a medieval toll-booth for people coming to trade in the market, and is therefore known as the Tolsey.

▼ The Old Bull Ring Tavern c1965 L111168

What was a wine shop in 1892 with an ale store next door has grown to take over both buildings, and it is now the Olde Bull Ring Tavern. The name comes from the fact that this area was formerly the site of the cattle market.

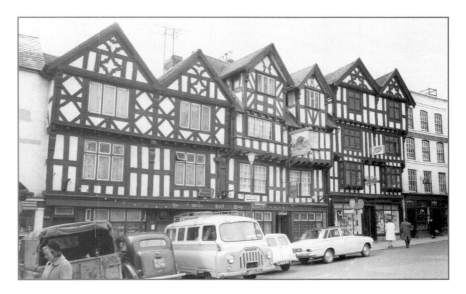

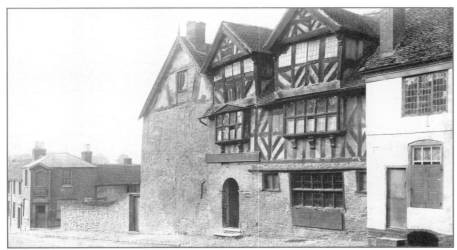

◀ Lane's Asylum 1892

30835

An unfortunate name; this building is now known simply as Lane's House, and is a beautiful private house. It was once a workhouse, and later an almshouse giving asylum to the poor, hence its name.

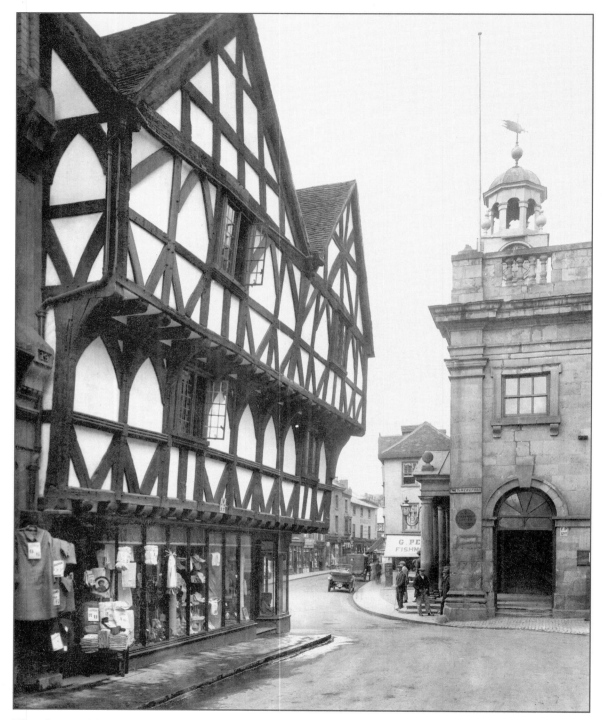

King Street 1923 73779
This wonderful building leaning into the street dates from the early 1400s. High vehicles such as tourist coaches
have to take great care negotiating this corner, and the jetties (as the overhanging floors of such buildings are
called) often show signs of having been recently struck and repaired.

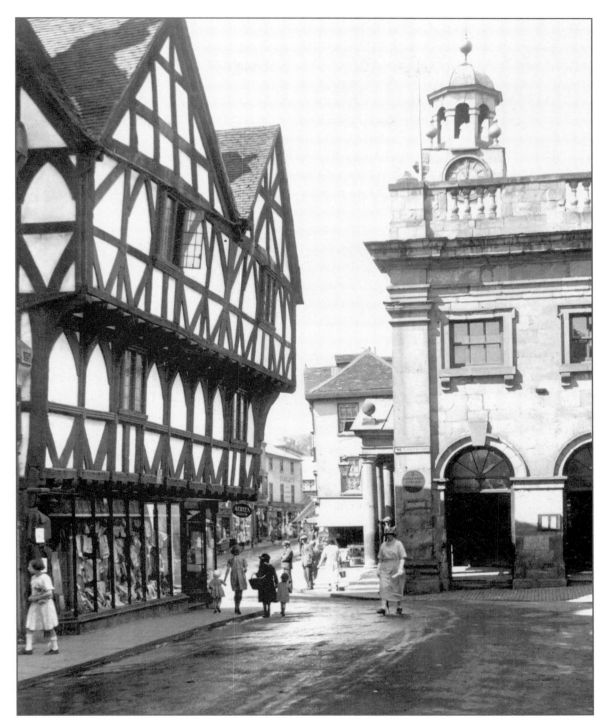

King Street c1955 L111021
The shop was originally owned by the Palmer's Guild. The Guild was a religious organisation; it invested heavily in property, using the profits to support the church, almshouses and, in Ludlow, a school. See if you can notice the same building (from another direction) in 1892 when it was covered in plaster. This was finally stripped in 1913.

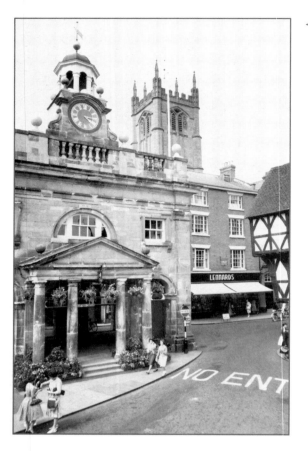

◄ The Butter Cross c1960 L111090

The Butter Cross was built in 1744 at a cost of £1,000 as a Town Hall, and ever since it has dominated the view along Broad Street. It served as a butter market, hence its name. The upper floor was used for a school – the Blue Coat Charity School.

▼ The Butter Cross and the Church 1892 30827

This wonderful picture reminds us of the rural community that Ludlow serves. Notice the milk churn on its wheeled carrier to the left, with the boy in the foreground collecting his milk. The notice on the side of the Butter Cross is an announcement about an infestation of sheep scab.

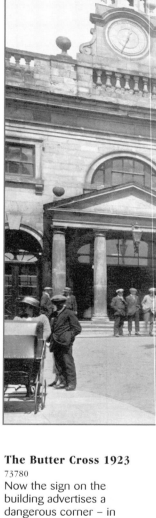

The Butter Cross 1923 73780

Now the sign on the building advertises a dangerous corner – in those days the road was still being used for two-way traffic. Until quite recently the upper floor of the Butter Cross was used as a museum for the town and was described in 1972 by one visitor as 'the best local museum I've seen in Britain'.

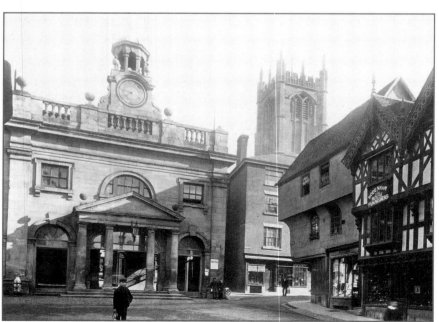

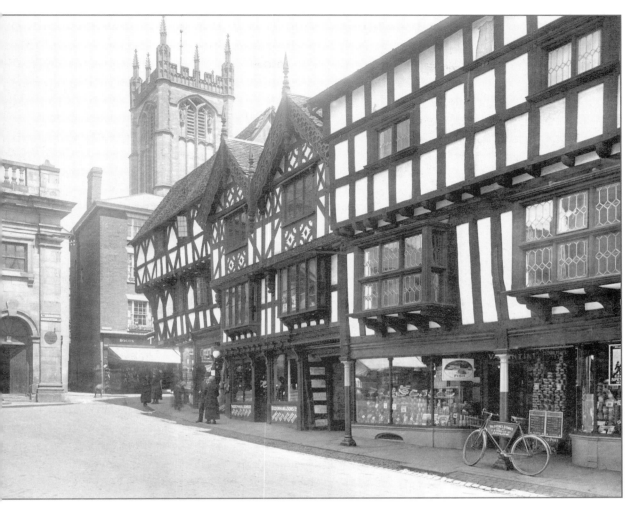

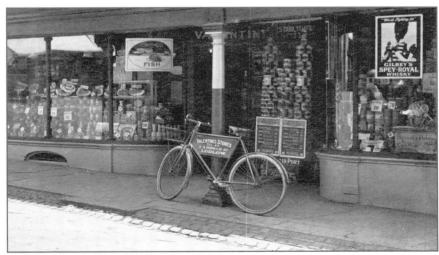

◀ **Extract From**
The Butter Cross 1923
73780

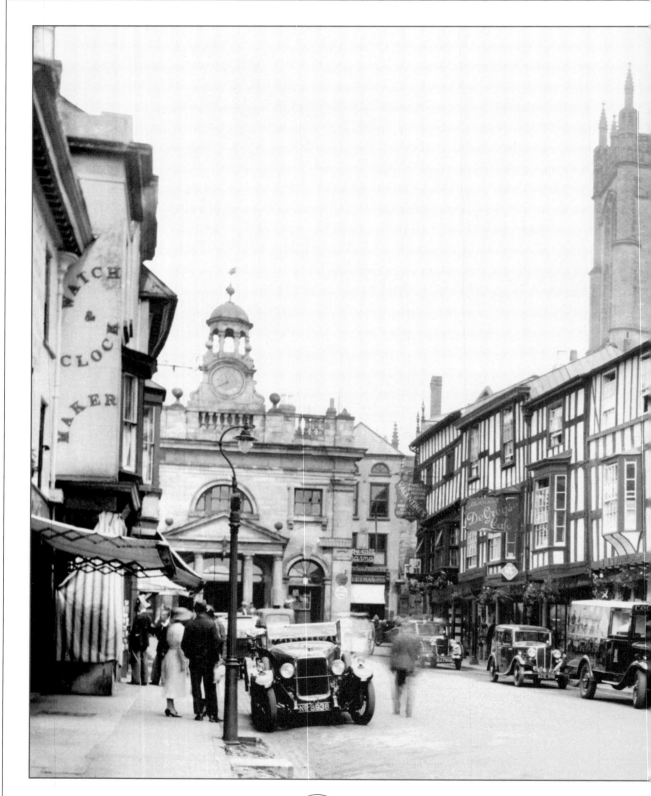

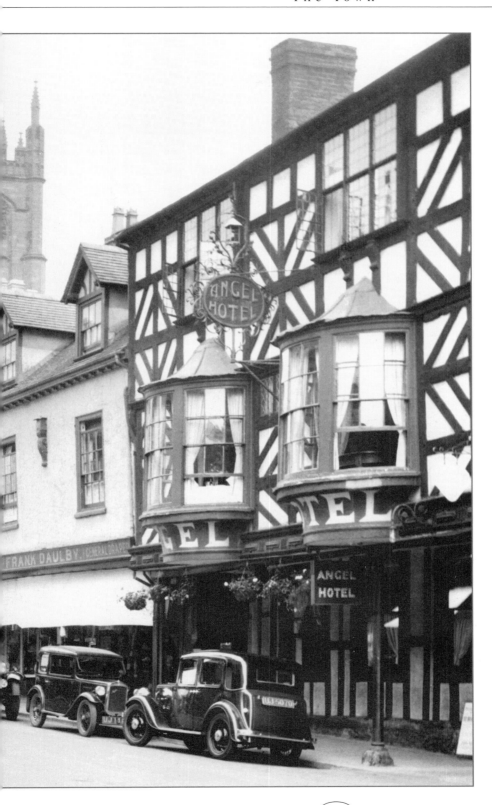

Broad Street and the Angel Hotel 1936 87393
The Angel Hotel has recently been sold and refurbished as shops and apartments. Founded as a hotel in 1555, it was therefore much older than the Feathers. One of its most famous visitors was Admiral Nelson.

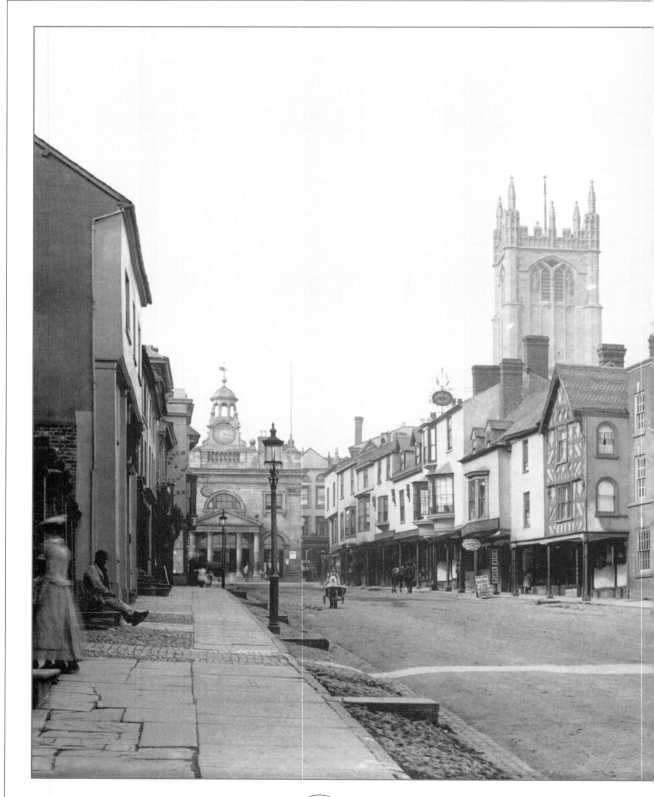

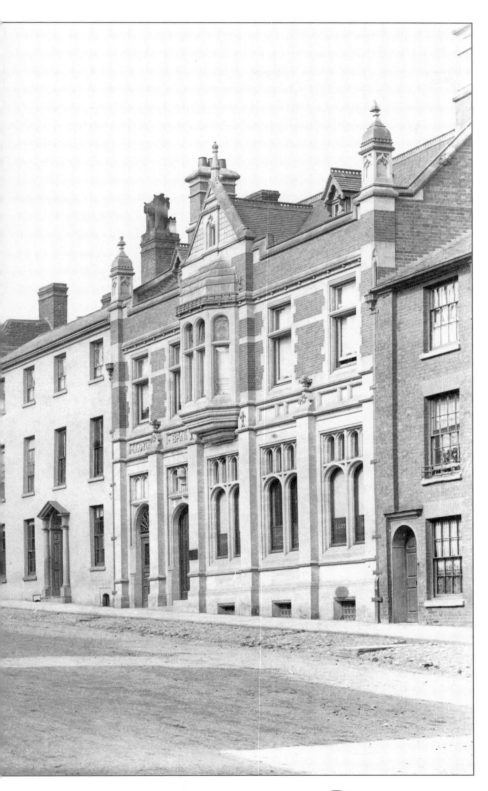

Broad Street 1892

30826

The fine building on the right is Lloyds Bank. The bank was founded in the 1700s, and its original logo was a beehive (representing thrift and industry); on old branches these can sometimes still be found. Here there is a beehive carved over the doorway.

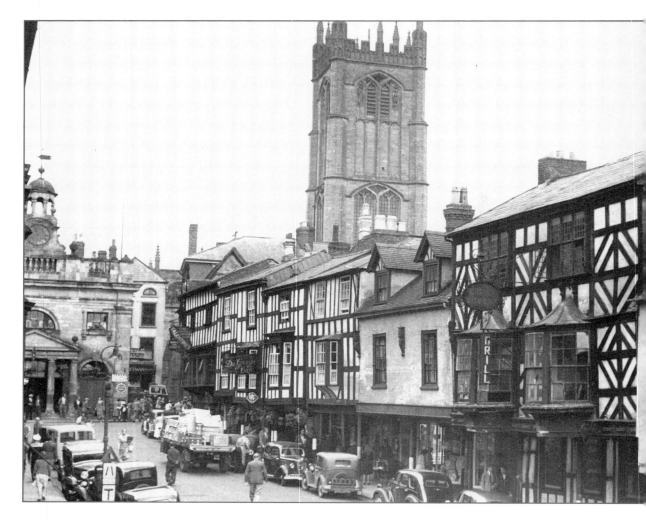

◀ **Broad Street c1965**
L111171
Broad Street is a wonderful mixture of varying architectural styles. This is the same street as in photograph No 30826 looking downhill. It was viewing Broad Street that led Nikolaus Pevsner in his book on Shropshire to describe the street as 'one of the most memorable streets in England'.

◄ Broad Street c1955

L111040

Here we see traffic congestion in the 1950s. Also, the traffic is facing both ways; looking at this picture, it is easy to see why the flow of movement later needed to be regulated.

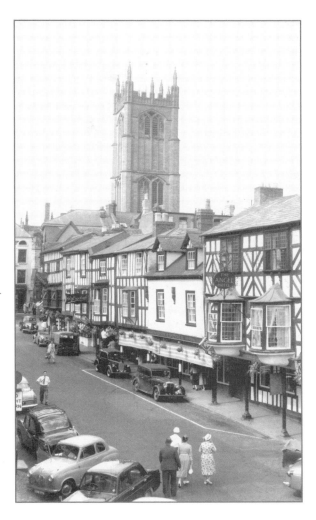

Broad Street c1960 ►

L111093

In all these photographs the tower of St Lawrence's church dominates the town. And yet, visiting the church one finds its entrance has become totally lost amongst the small streets and alleyways – it is surprising how the area immediately around it has been encroached upon over the centuries.

◄ The Broad Gate 1923

73777

The very narrow Broad Gate is obviously named for the street rather than the width of the gate. It is the south gate in the medieval town walls; it is now almost lost amongst the later buildings that have since been attached to it.

▼ **The Broad Gate c1965** L111176
In this series of photographs, notice how the Wheatsheaf Inn gets smaller and smaller as we go back in time. The pub is reputed to be haunted by a man who may be one of the 'rogues, vagabonds, beggars and such like' who have used this inn in the past.

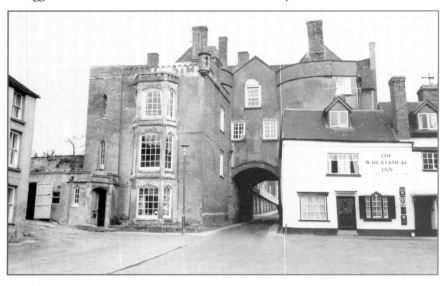

▼ **The Broad Gate c1955** L111065
Originally the town wall would have been surrounded by a ditch, which the Wheatsheaf pub now straddles. The house on the left of the gate was added in the mid 18th century, although the windows are slightly later.

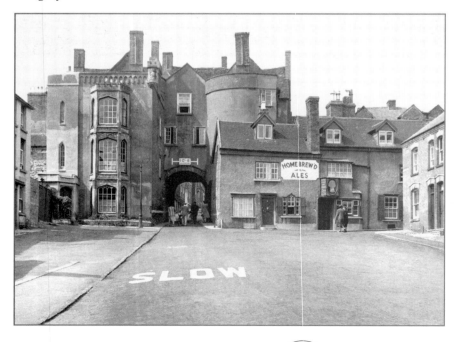

▲ **Lower Broad Street 1903** 50724
Notice how the street level has been altered – it is raised in the foreground, but beyond the gate it has obviously been cut lower. This was to make the incline of the road easier for stagecoach traffic; it was done by the famous Scottish engineer, Thomas Telford.

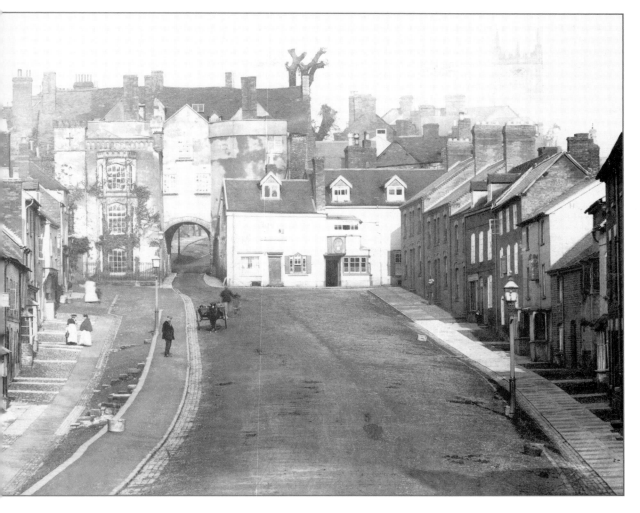

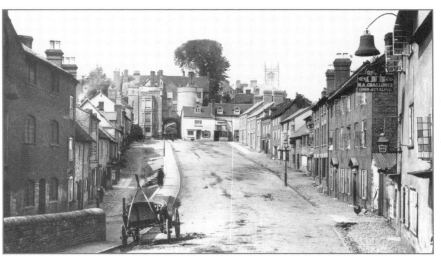

◀ **Lower Broad Street 1892**
30825
The Bell Inn with its 'good stabling' is obviously for visitors to the town (those who cannot afford to stay at the Feathers or the Angel), while the Wheatsheaf probably serves an even poorer local clientele. The carriage sitting on the left is made of wicker-work.

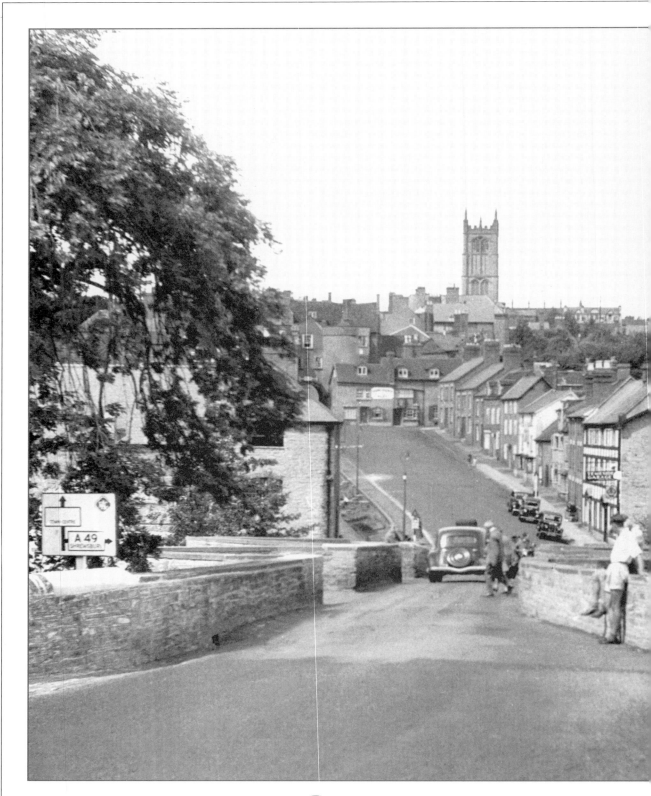

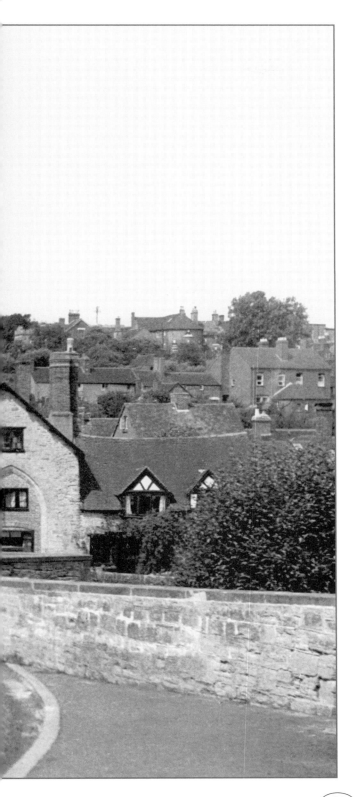

Neighbouring
Ludford

From Ludford Bridge c1955 L111067
The Bell Inn, just across the bridge, has now disappeared - or rather, been restored to an earlier form. It was once a hospital, founded in the 13th century, and like all hospitals of the time was therefore just outside the town walls.

▼ The Ludford Bridge 1896 38147

The Ludford Bridge, in its present form, dates from the 15th century. The first bridge on this site, however, was probably built in Norman times to give easy access to the castle and its rapidly developing market town.

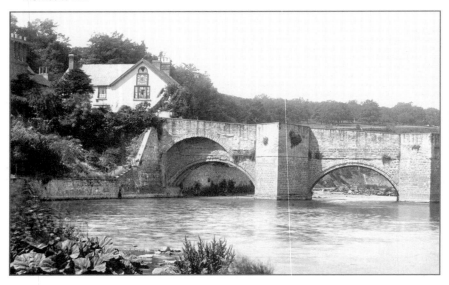

▼ The Weir and the Mill 1892 30796

This is known as the Horseshoe Weir because of its shape. There are mill buildings on both sides of the river. Mills were not just used for corn. In Shropshire many medieval mills were 'fulling' mills where cloth was beaten (fulled) and cleaned.

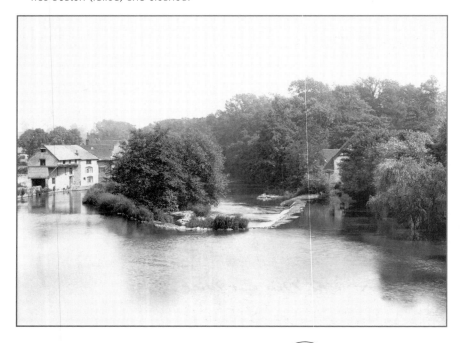

▲ The Ludford Bridge 1892 30795

There was once a small chapel sitting on the bridge called St Catherine's. It was pulled down sometime in the 18th century. Here people would pray for a safe journey as they set out, or give thanks for a safe arrival.

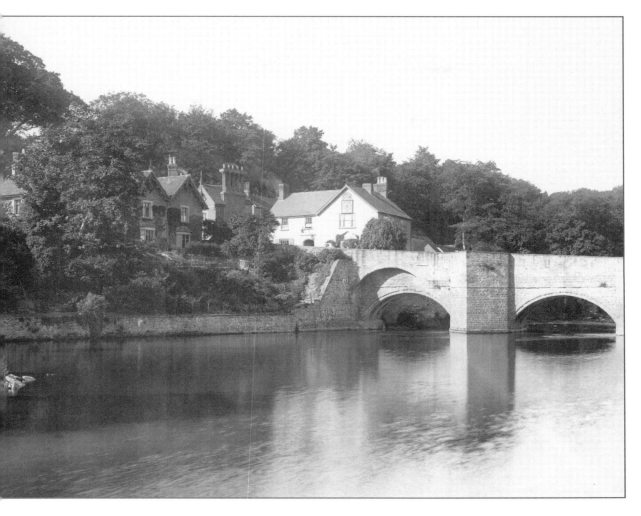

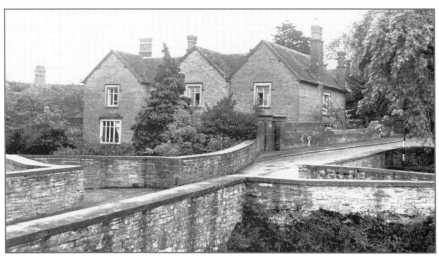

◀ **Ludford Lodge c1960**
L111076
This building was, until very recently, a youth hostel, but is now privately owned once again. Notice how, in the foreground, passing places have been built into the bridge. Its narrow width means that access has to be one-way and is controlled by traffic lights these days.

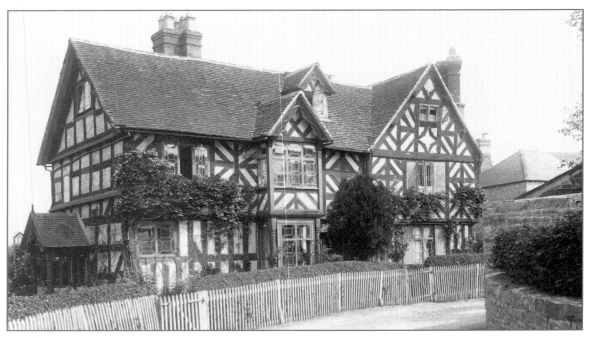

Ludford, The Old Bell Inn 1892 30834
This beautiful building is now a private house called the Old Bell House. It dates from 1614. Was it perhaps the 'old' Bell to distinguish it from the other Bell Inn we have just seen nearby at the bottom of Broad Street?

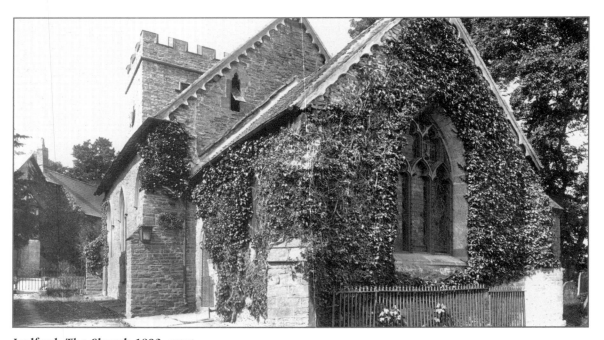

Ludford, The Church 1892 30836
This is St Giles' church. Like so many St Giles' churches up and down the country, this one is outside a large town and had a hospital linked with it. St Giles was the patron saint of lepers, hence the connection.

Beside
The River Teme

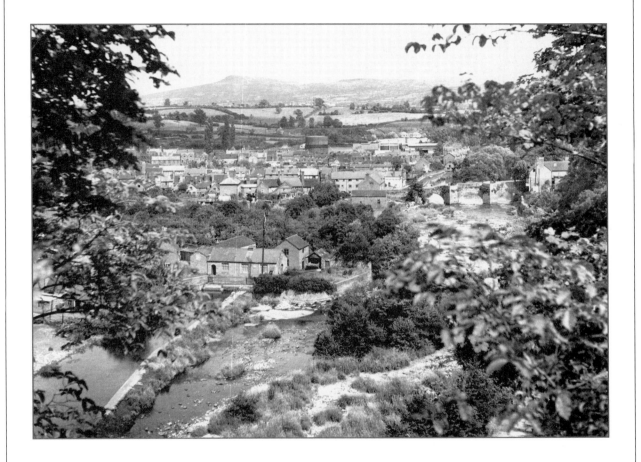

The Ludford Bridge and Clee Hill c1955 L111062
Many of the early views from Whitcliffe towards the Ludford Bridge
are impossible to see these days because of the growth of the
trees. In this relatively recent photograph the trees
are already fast encroaching.

▼ The Ludford Bridge 1892 30794

This earlier photograph shows fewer trees to obscure the view. Notice the children playing by the river in this picture. These days you are far more likely to see canoeists here.

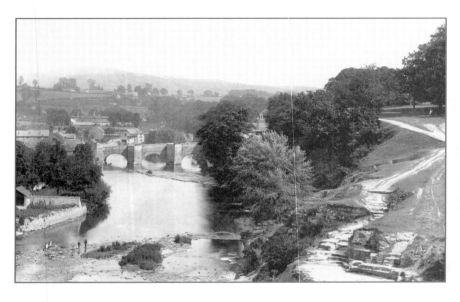

▼ General View 1936 87391

This is a lovely view of the town, dominated as always by the tower of St Lawrence's, the finest parish church in Shropshire. Its tower stands 135 feet high and was built quite late in the church's history, in the mid 15th century.

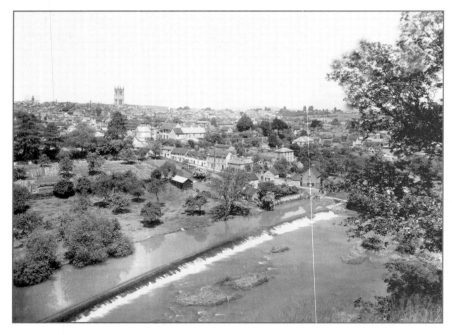

▲ Mill Street 1896 38140

Mill Street is one of Ludlow's main streets; it leads from the Victorian town hall (notice its cupola on the left of the picture) down to the River Teme. These photographs clearly show how water was channelled behind the weir to the mill.

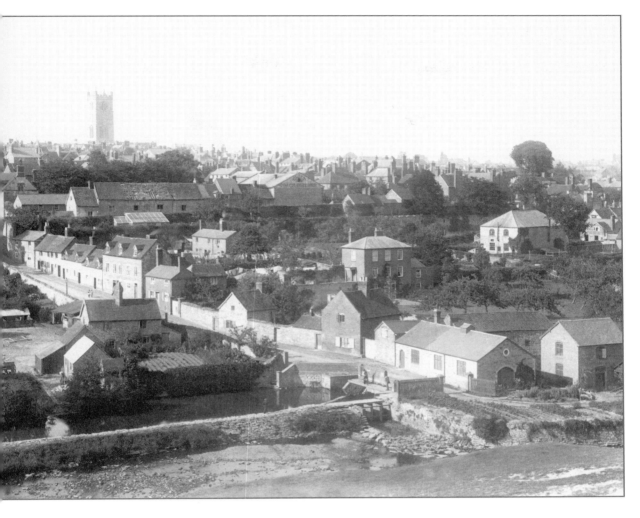

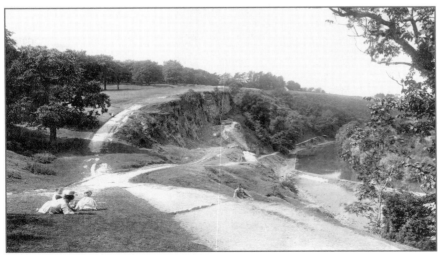

◀ **The Whitcliffe 1892** 30801
From the early 1200s the
people of Ludlow used this
as common land where they
could graze their livestock,
gather hay and firewood
and quarry building stone.
The jagged outline of a
former quarry can be seen
easily here.

▼ **The Bread Walk 1923** 73789

The path alongside the river was laid out in 1850 using unemployed labourers to do the work. They were paid in bread, and so it became known as the Bread Walk.

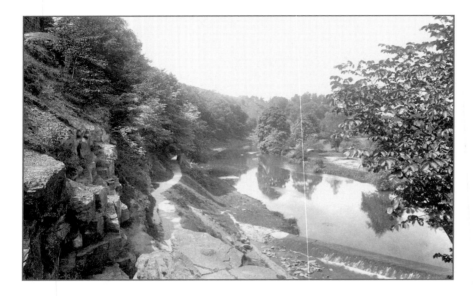

▼ **The Walk on Whitcliffe Common 1923** 73786

The common is still very popular with local people for walks, although at 52 acres it is now only a third of the size it was in medieval times.

▲ **View of Dinham 1892**
30798
Notice the allotments just below the town in this picture. With the encroachment of buildings on so much land close to towns like this, it is good to know that these allotments still survive.

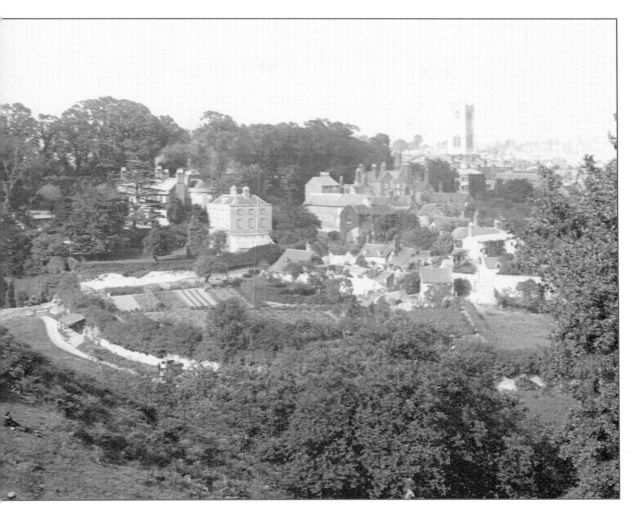

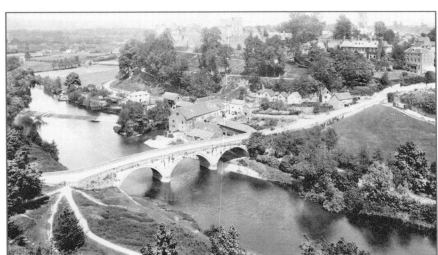

◀ **Castle Hill and Dinham Bridge 1923** 73768
In this photograph it is possible to make out Dinham House and Dinham Lodge, two fine Georgian buildings to the right of the castle. Lucien Bonaparte, brother of Napoleon, was imprisoned in the former in 1811. His household, while imprisoned here, included seven children and 23 servants!

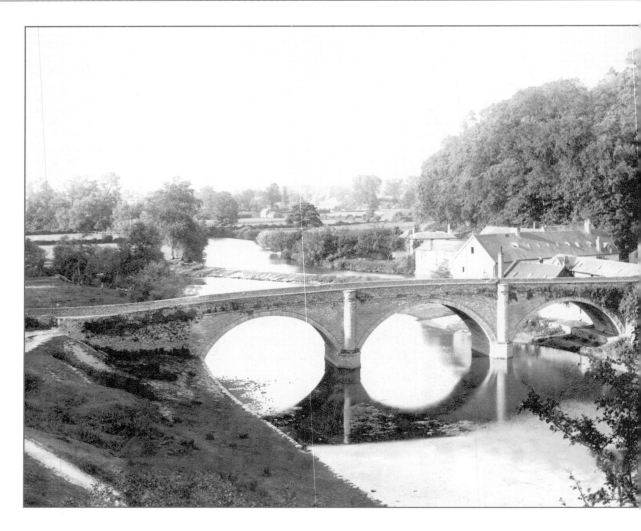

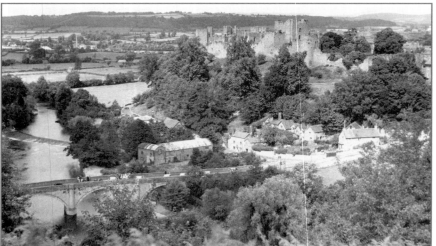

◄ **The Castle and the Bridge c1955** L111063
Notice the cattle being driven into town – it must have been a Monday, for this is when, according to the poet A E Housman, 'Ludlow market hums'.

◄ Dinham Bridge 1892

30822

At this time in its history the Dinham Bridge was probably still known locally as the New Bridge. The present bridge was built in 1823 on possibly medieval stone piers, replacing a much older bridge. Sometimes in dry weather when the river is low the old piers can still be seen.

▼ Dinham Bridge 1896

38145

In these views you can clearly see another weir just beyond the bridge. In fact, there were several weirs all along this stretch of the River Teme; they were built to hold up the river so that there would always be water available to power the mills.

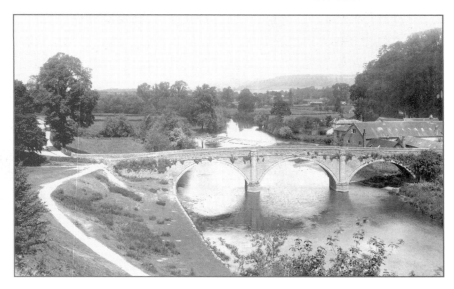

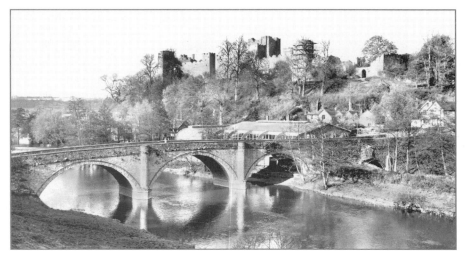

◄ The Castle and Dinham Bridge c1965

L111197

The unusual structures just behind the bridge were the swimming baths that were opened in 1961. The swimming baths did not last too long, and they have since been moved elsewhere.

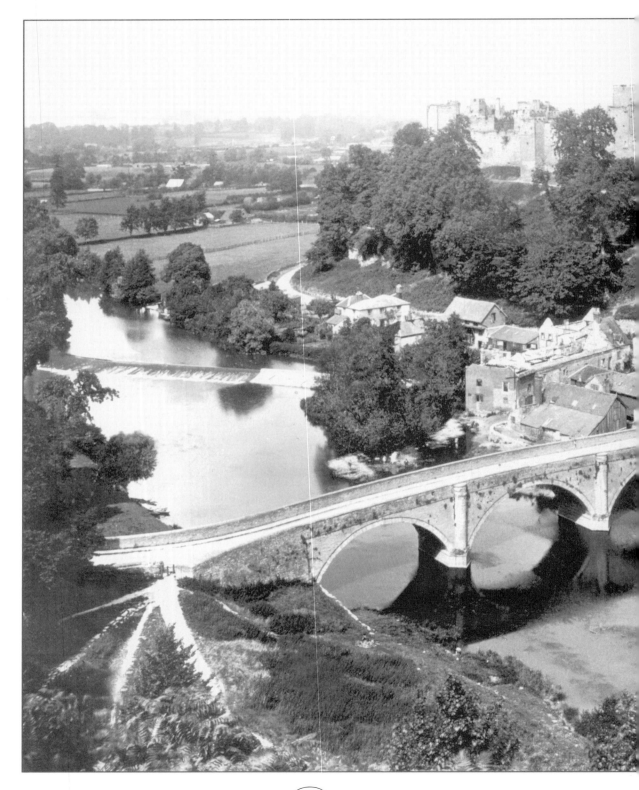

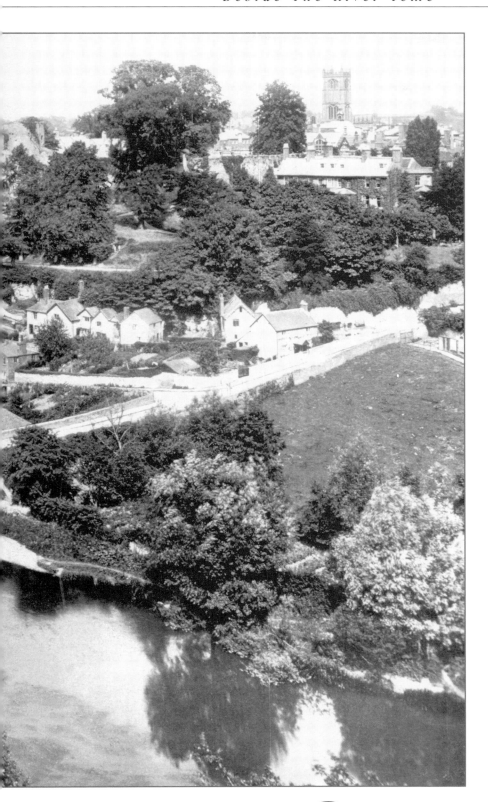

Dinham Bridge and the Castle c1955

L111018

These days Ludlow is the gourmet capital of Great Britain. Apart from London, Ludlow's restaurants have, between them, more Michelin stars than are to be found anywhere else in the country. One of these restaurants is Mr Underhill's; it can be found amongst the cluster of buildings beyond the bridge overlooking Dinham weir.

Around Ludlow

East into The Clee Hills

Angelbank c1955 A337017
Angelbank is a lovely name for an otherwise uninspiring hamlet. It sits on the road from Ludlow to Cleobury Mortimer where the land starts to rise into the Clee Hills. It does, therefore, have wonderful views.

▼ **Titterstone Clee c1955** T338014
Titterstone Clee is one of the highest of the Clee Hills. Just over the
brow of the hill nowadays there sits a huge golf ball -- it is a radar
dish, built to protect the western world during the Cold War, and now
used for civil aviation.

▼ **Clee Hill, Caynham Road c1960** C505016
This is typical of the views from the Clee Hills, looking down from what
is still essentially open sheep country over the fields and mixed farming
communities below.

▲ **Clee Hill, Cornbrook
Bridge 1911** 63202
We are still on the main
road to Cleobury
Mortimer. It is much
wider now (and busier),
with the road extending
to the right and a modern
metal fence replacing the
stone walls.

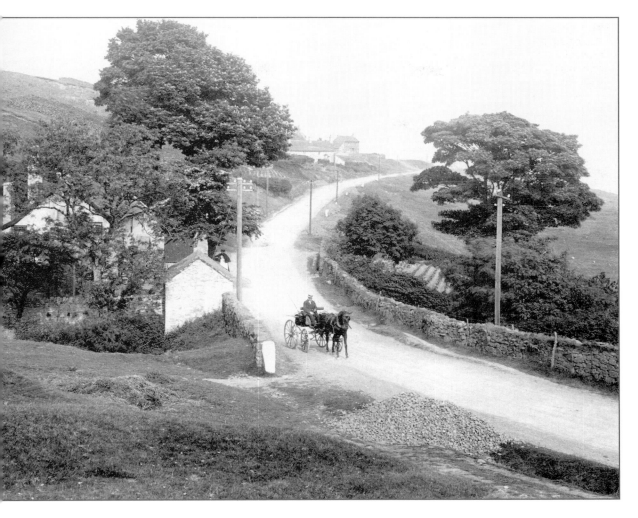

◄ **Clee Hill 1911** 63203
The people who lived in the Clee Hills were always seen by outsiders as being very strange; since they had their own dialect and customs, they were seen almost as a race apart. They were known elsewhere in Shropshire as the 'Hill Folk'.

▼ **Clee Hill 1911** 63204

These days, however, the wonderful views and open landscapes bring many strangers to the area – it is wonderful walking country. It is always windy and cold though, even on the sunniest days! Incidentally, the Clee Hills are the only hills in England that are actually marked on the Mappa Mundi, one of the four oldest maps in the world.

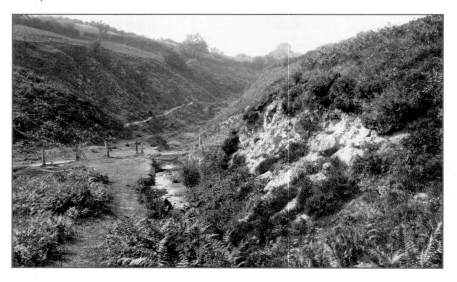

▼ **Clee Hill, The Quarry 1911** 63207

The hills have been quarried since the beginnings of time, producing a very hard, almost black, volcanic basalt known as dhustone from the Welsh word for black. The wagon in the picture is being pulled up the rails by a hawser with two men to hold it steady.

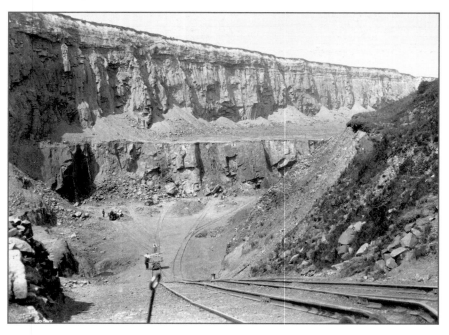

▲ **Knowbury
The Church 1911** 63200
Arthur Mee describes the village as having 'little beauty of its own but (it) borrows glory from afar'. I agree. It is another unexciting village in itself, but the views from it are stunning. We are still 900 feet up in the hills here.

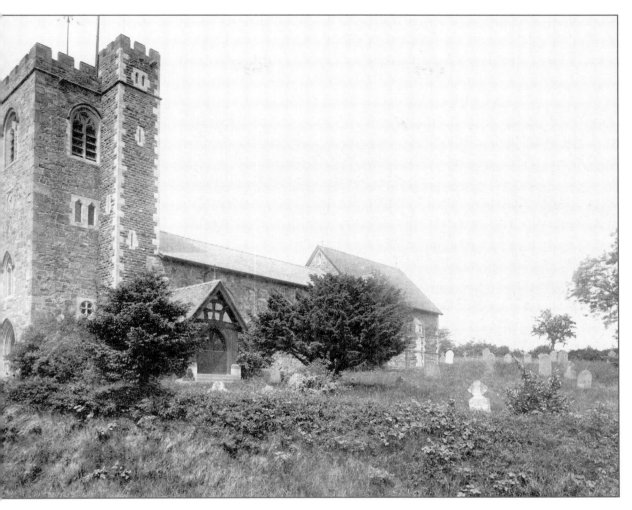

◀ **Nash, The Church and the Sports Field c1965**
N222209
St John the Baptist church serves a very small local community; it was originally built as a local chapel of ease serving Burford church a few miles to the south. In this photograph it would appear that a local scout group, perhaps, is camping in the sports field.

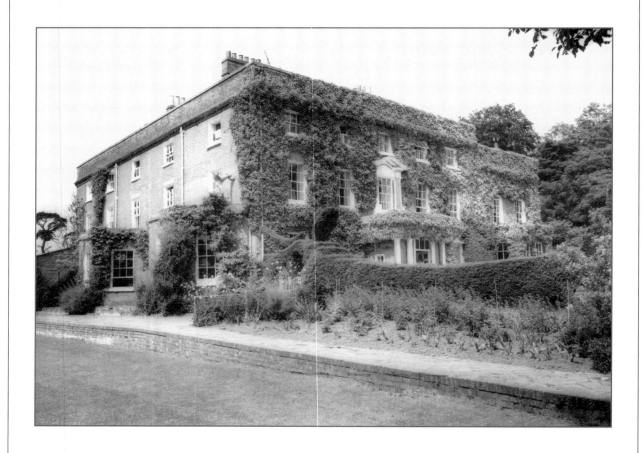

Nash
The Court c1965 N222205
This is still a beautiful house, with much
of the ivy pulled off today. Nash Court
was built in 1760 and overlooks the
playing field between it and the church.

Around Ludlow
South Along The River Teme

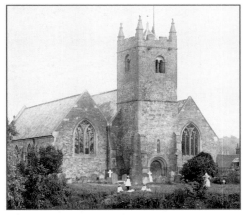

Tenbury Wells, The Church 1892 30851A

Tenbury Wells, The Church 1892
We are just across the border in Worcestershire here. St Mary's church sits overlooking the River Teme (also the county boundary). Subject through the centuries to frequent floods, the church we see today is really the result of restoration work in the 19th century.

Tenbury Wells, Teme Street 1898
Known in the past only as Tenbury, the Wells in its name was added in the late 19th century as a deliberate marketing ploy to promote the local mineral water. The waters from the Malvern Hills nearby were then, as now, much better known.

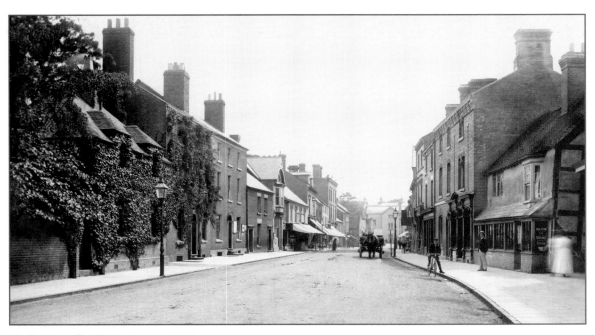

Tenbury Wells, Teme Street 1898 41723

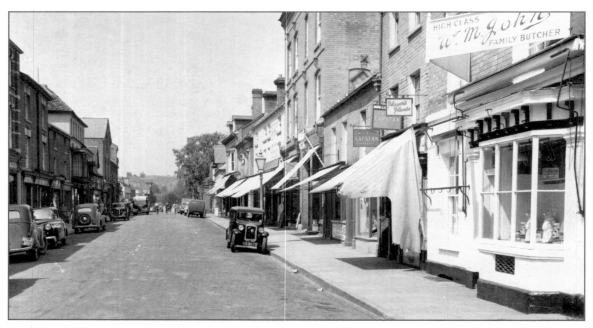

Tenbury Wells, Teme Street c1955 T22053
Today Tenbury is no longer connected in the minds of most people with mineral water. Instead, these days the town is famous world-wide for its mistletoe (and holly) sales in the weeks leading up to Christmas each year. It is 'the town in the orchard', and where you have apple trees you also get mistletoe.

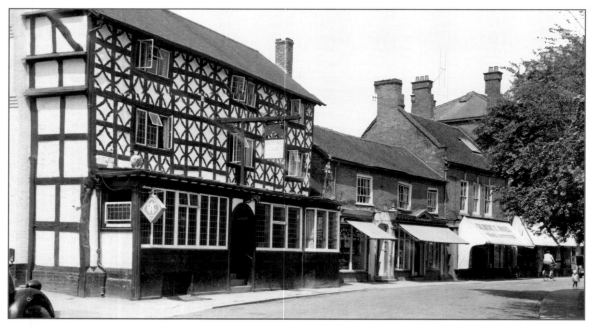

Tenbury Wells, The Royal Oak Hotel c1955 T22054
The Royal Oak would appear to have hardly changed over time. It is said that there was once a beam in the building dated 1581, but unfortunately there was a fire in 1937; if such a beam ever existed, it must have been destroyed then.

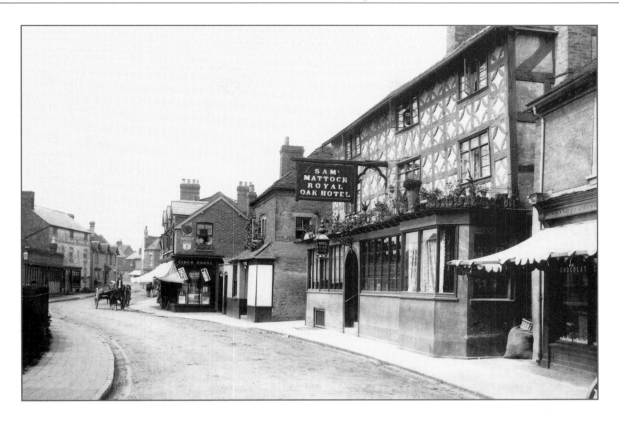

Tenbury Wells
Market Street 1898 41720
Mr Sam Mattock was not only the
landlord here, but he also used the
building as a corn exchange; when
sales had been completed, farmers
would seal their deals with a noggin of
whisky! Notice also the Clock House –
so-called because of the clock
on the side of the building.

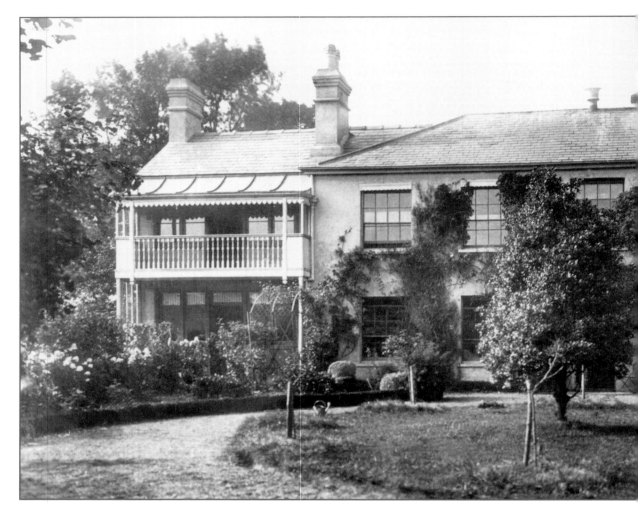

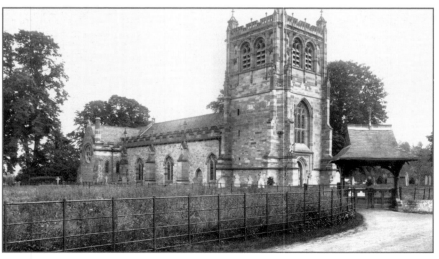

◄ **Burford
The Church 1898**
41729
We are back on the Shropshire side of the county boundary again. Most visitors to Burford these days go to the house and ignore the lovely church. The reason is simple – Burford House next door is home to England's National Clematis Collection.

Tenbury Wells The Cottage Hospital 1898

41742

Unlike far too many cottage hospitals in small towns, this one still survives; its façade is still instantly recognisable. The hospital was founded by Mrs Annabella Prescott in 1871.

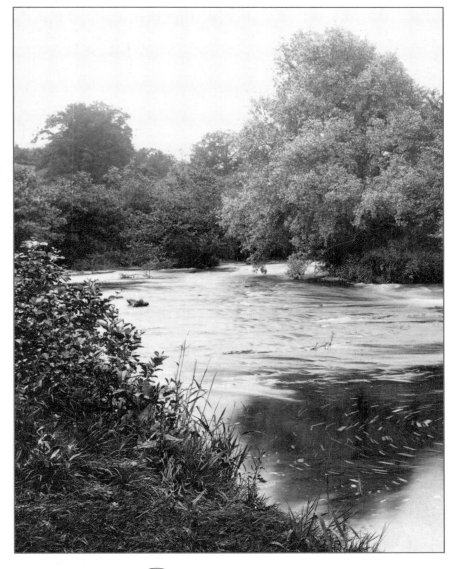

Little Hereford ▶ The River Teme 1898

41749

And we cross out of the county once more. Little Hereford, as its name implies, is actually in the county of Herefordshire; but boundaries being the arbitrary things they are, it actually sits between Tenbury Wells in Worcestershire and Ludlow in Shropshire.

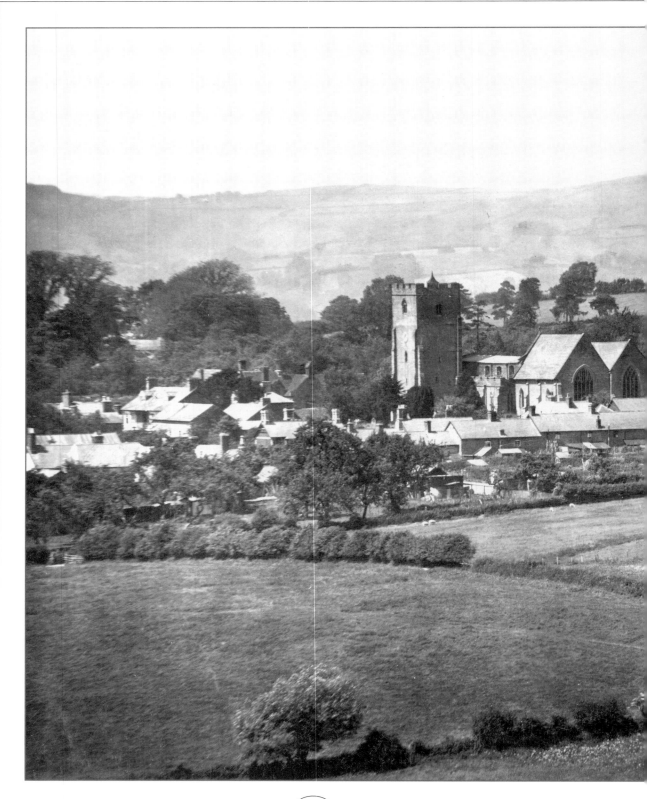

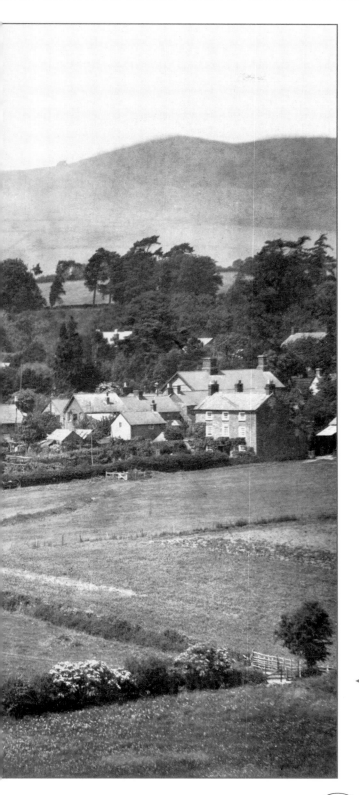

Around Ludlow

Towards The West

▼ **Pipe Aston, The Church,
the Tympanum c1965** L111503
The survival of this wonderful tympanum in St
Giles' church is remarkable, since it dates from
Norman times. The carving is so sharp that it is
easy to make out the lamb of God in the centre
supported by the eagle of St John on one side
and the winged bull of St Luke on the other.

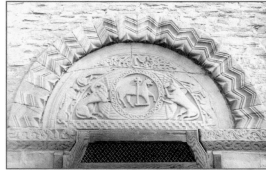

◄ **Leintwardine,
The Village c1955** L214029
Some people think that Leintwardine means the
homestead by the fast-flowing river; others that it
means an enclosure on the River Lent, an old Celtic
name meaning a torrent. Who knows for sure?
Certainly the site has been occupied for a long time
– even the Romans had a settlement here.

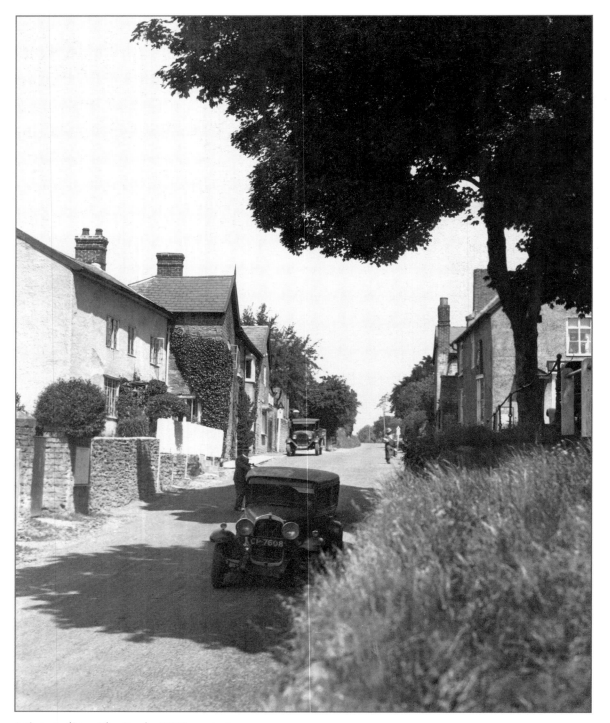

Leintwardine, The Bank c1955 L214016
The Bank refers to the higher ground on the right of what officially is known as the High Street. Parallel to this the next street in the village is called Watling Street; it does indeed follow the line of an old Roman road running from north to south along the edge of the Welsh hills.

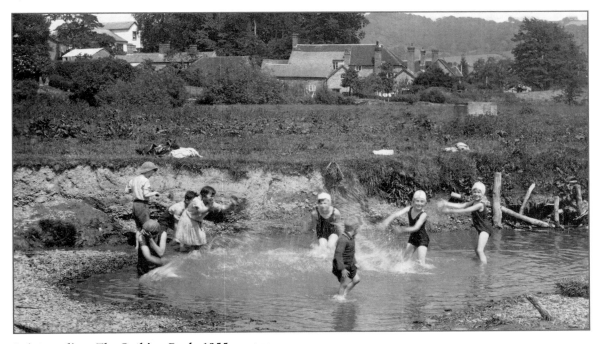

Leintwardine, The Bathing Pool c1955 L214022
This is a delightful picture of local children playing in the river on a hot summer's day. Some of them have come to play with every intention of getting wet with their swimming costumes and even bathing caps.

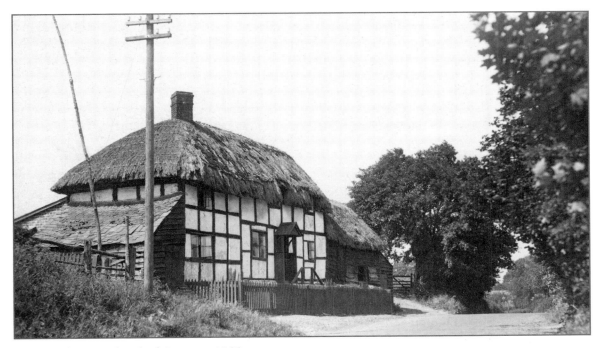

Leintwardine, A Thatched Cottage c1955 L214032
The Plough Cottage stands beside the road to Ludlow – it is a 16th-century building and was once an inn, but it is now, and has been for some time, a private house.

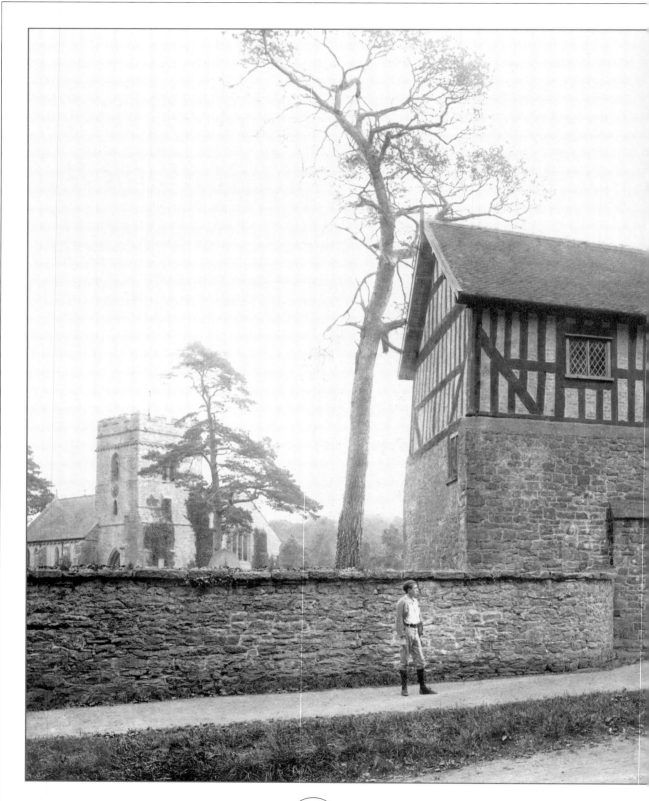

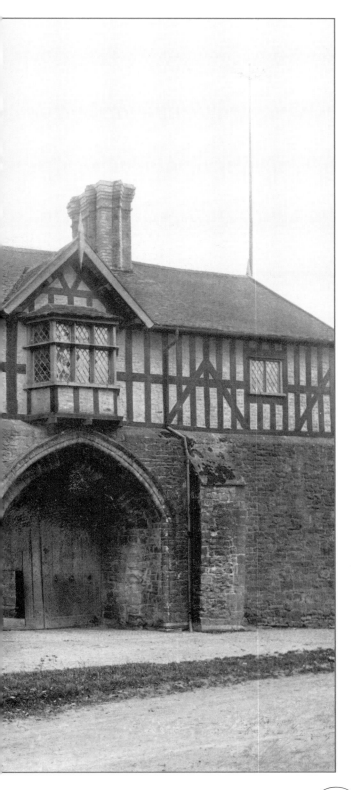

Around Ludlow

Towards The North

Bromfield, The Priory Gatehouse 1892 30844
St Mary's church and its gatehouse are all that
survive of a medieval Benedictine priory that was
dissolved, along with so many others, in the reign
of Henry VIII in the 1500s.

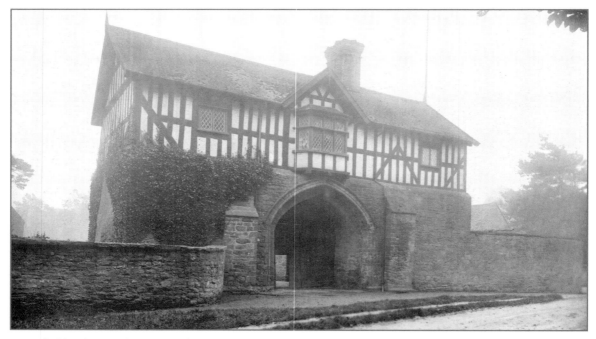

Bromfield, The Gatehouse 1924 76176
Today the Gatehouse has been totally restored; it is available for renting as a holiday home through a company called the Landmark Trust, which specialises in saving old buildings and restoring them for this purpose.

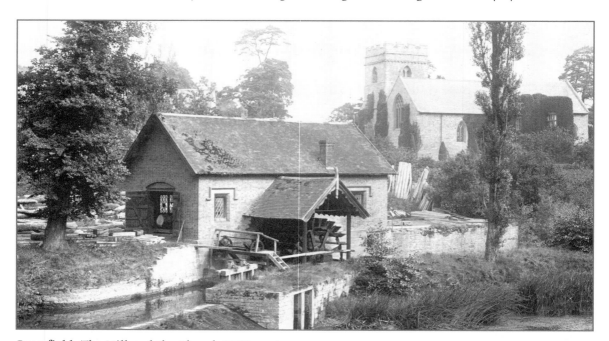

Bromfield, The Mill and the Church 1892 30842
Much of St Mary's church, behind the mill, was used as a private house after the Dissolution; the ivy-covered remains of part of it can be seen here, attached to the right of the church. It was finally restored as a church in the mid 1600s.

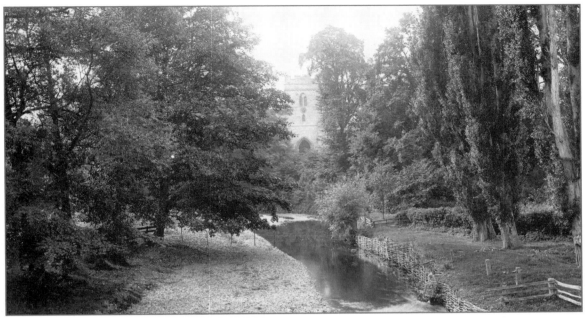

Bromfield, The Church 1892 30843
Soon after the church's restoration in the 1600s, the interior was repainted; the painting on the chancel ceiling still survives. It has been very aptly described as 'the best example of the worst style of ecclesiastical art', and its hideous cherubs have to be seen to be believed.

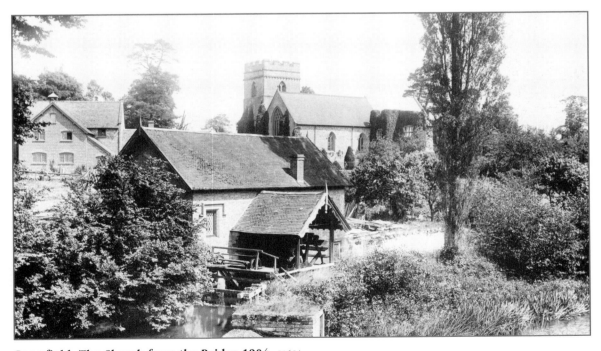

Bromfield, The Church from the Bridge 1904 51654
The mill in the foreground has long since ceased to function as a mill. It sits just by the entrance to Oakly Park; this is the only house in the county previously owned by Robert Clive, Clive of India, that is still owned by his descendants.

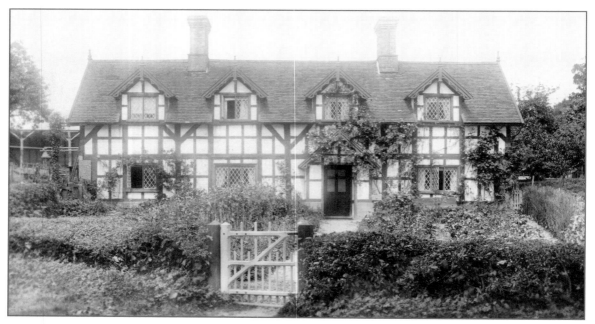

Bromfield, A Cottage 1904 51657

Near the village is a field with the strange name of Crawl Meadow. Legend has it that a local girl wanted to marry a poor man against her family's wishes. Her father said she could only have as her dowry as much land as she could crawl across in a day – she crawled four miles.

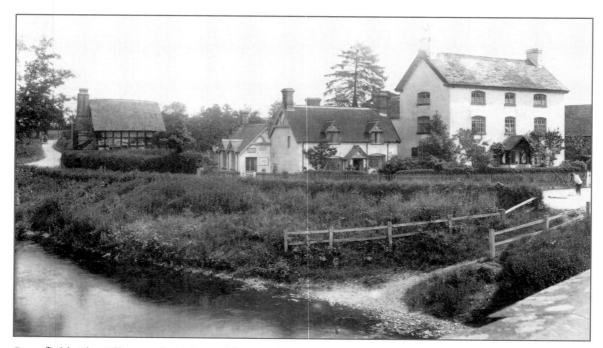

Bromfield, The Village and the Post Office 1904 51655

Bromfield's post office is the building in the centre of the picture. It still serves as a post office and village store to this day. Notice the man on the right who is sweeping the road.

Index

Frith Book Co Titles

www.frithbook.co.uk

The Frith Book Company publishes over 100 new titles each year. A selection of those currently available are listed below. For latest catalogue please contact Frith Book Co.

Town Books 96pp, 100 photos. County and Themed Books 128pp, 150 photos (unless specified). All titles hardback laminated case and jacket except those indicated pb (paperback)

Around Bakewell	1-85937-113-2	£12.99	Around Great Yarmouth	1-85937-085-3	£12.99
Around Barnstaple	1-85937-084-5	£12.99	Around Guildford	1-85937-117-5	£12.99
Around Bath	1-85937-097-7	£12.99	Hampshire	1-85937-064-0	£14.99
Berkshire (pb)	1-85937-191-4	£9.99	Around Harrogate	1-85937-112-4	£12.99
Around Blackpool	1-85937-049-7	£12.99	Around Horsham	1-85937-127-2	£12.99
Around Bognor Regis	1-85937-055-1	£12.99	Around Ipswich	1-85937-133-7	£12.99
Around Bournemouth	1-85937-067-5	£12.99	Ireland (pb)	1-85937-181-7	£9.99
Brighton (pb)	1-85937-192-2	£8.99	Isle of Man	1-85937-065-9	£14.99
British Life A Century Ago	1-85937-103-5	£17.99	Isle of Wight	1-85937-114-0	£14.99
Buckinghamshire (pb)	1-85937-200-7	£9.99	Kent (pb)	1-85937-189-2	£9.99
Around Cambridge	1-85937-092-6	£12.99	Around Leicester	1-85937-073-x	£12.99
Cambridgeshire	1-85937-086-1	£14.99	Leicestershire (pb)	1-85937-185-x	£9.99
Canals and Waterways	1-85937-129-9	£17.99	Around Lincoln	1-85937-111-6	£12.99
Cheshire	1-85937-045-4	£14.99	Lincolnshire	1-85937-135-3	£14.99
Around Chester	1-85937-090-x	£12.99	London (pb)	1-85937-183-3	£9.99
Around Chichester	1-85937-089-6	£12.99	Around Maidstone	1-85937-056-x	£12.99
Churches of Berkshire	1-85937-170-1	£17.99	New Forest	1-85937-128-0	£14.99
Churches of Dorset	1-85937-172-8	£17.99	Around Newark	1-85937-105-1	£12.99
Colchester (pb)	1-85937-188-4	£8.99	Around Newquay	1-85937-140-x	£12.99
Cornwall	1-85937-054-3	£14.99	North Devon Coast	1-85937-146-9	£14.99
Cumbria	1-85937-101-9	£14.99	Northumberland and Tyne & Wear		
Dartmoor	1-85937-145-0	£14.99		1-85937-072-1	£14.99
Around Derby	1-85937-046-2	£12.99	Norwich (pb)	1-85937-194-9	£8.99
Derbyshire (pb)	1-85937-196-5	£9.99	Around Nottingham	1-85937-060-8	£12.99
Devon	1-85937-052-7	£14.99	Nottinghamshire (pb)	1-85937-187-6	£9.99
Dorset	1-85937-075-6	£14.99	Around Oxford	1-85937-096-9	£12.99
Dorset Coast	1-85937-062-4	£14.99	Oxfordshire	1-85937-076-4	£14.99
Down the Severn	1-85937-118-3	£14.99	Peak District	1-85937-100-0	£14.99
Down the Thames	1-85937-121-3	£14.99	Around Penzance	1-85937-069-1	£12.99
Around Dublin	1-85937-058-6	£12.99	Around Plymouth	1-85937-119-1	£12.99
East Sussex	1-85937-130-2	£14.99	Around St Ives	1-85937-068-3	£12.99
Around Eastbourne	1-85937-061-6	£12.99	Around Scarborough	1-85937-104-3	£12.99
Edinburgh (pb)	1-85937-193-0	£8.99	Scotland (pb)	1-85937-182-5	£9.99
English Castles	1-85937-078-0	£14.99	Scottish Castles	1-85937-077-2	£14.99
Essex	1-85937-082-9	£14.99	Around Sevenoaks and Tonbridge		
Around Exeter	1-85937-126-4	£12.99		1-85937-057-8	£12.99
Exmoor	1-85937-132-9	£14.99	Around Southampton	1-85937-088-8	£12.99
Around Falmouth	1-85937-066-7	£12.99	Around Southport	1-85937-106-x	£12.99

Available from your local bookshop or from the publisher

Frith Book Co Titles (continued)

Around Shrewsbury	1-85937-110-8	£12.99		Around Torbay	1-85937-063-2	£12.99
Shropshire	1-85937-083-7	£14.99		Around Truro	1-85937-147-7	£12.99
South Devon Coast	1-85937-107-8	£14.99		Victorian & Edwardian Kent		
South Devon Living Memories					1-85937-149-3	£14.99
	1-85937-168-x	£14.99		Victorian & Edwardian Yorkshire		
Staffordshire (96pp)	1-85937-047-0	£12.99			1-85937-154-x	£14.99
				Warwickshire (pb)	1-85937-203-1	£9.99
Stone Circles & Ancient Monuments				Welsh Castles	1-85937-120-5	£14.99
	1-85937-143-4	£17.99		West Midlands	1-85937-109-4	£14.99
Around Stratford upon Avon				West Sussex	1-85937-148-5	£14.99
	1-85937-098-5	£12.99		Wiltshire	1-85937-053-5	£14.99
Sussex (pb)	1-85937-184-1	£9.99		Around Winchester	1-85937-139-6	£12.99

Frith Book Co titles available Autumn 2000

Croydon Living Memories (pb)				Worcestershire	1-85937-152-3	£14.99	Sep
	1-85937-162-0	£9.99	Aug	Yorkshire Living Memories	1-85937-166-3	£14.99	Sep
Glasgow (pb)	1-85937-190-6	£9.99	Aug				
Hertfordshire (pb)	1-85937-247-3	£9.99	Aug	British Life A Century Ago (pb)			
North London	1-85937-206-6	£14.99	Aug		1-85937-213-9	£9.99	Oct
Victorian & Edwardian Maritime Album				Camberley (pb)	1-85937-222-8	£9.99	Oct
	1-85937-144-2	£17.99	Aug	Cardiff (pb)	1-85937-093-4	£9.99	Oct
Victorian Seaside	1-85937-159-0	£17.99	Aug	Carmarthenshire	1-85937-216-3	£14.99	Oct
				Cornwall (pb)	1-85937-229-5	£9.99	Oct
Cornish Coast	1-85937-163-9	£14.99	Sep	English Country Houses	1-85937-161-2	£17.99	Oct
County Durham	1-85937-123-x	£14.99	Sep	Humberside	1-85937-215-5	£14.99	Oct
Dorset Living Memories	1-85937-210-4	£14.99	Sep	Lancashire (pb)	1-85937-197-3	£9.99	Oct
Gloucestershire	1-85937-102-7	£14.99	Sep	Liverpool (pb)	1-85937-234-1	£9.99	Oct
Herefordshire	1-85937-174-4	£14.99	Sep	Manchester (pb)	1-85937-198-1	£9.99	Oct
Kent Living Memories	1-85937-125-6	£14.99	Sep	Middlesex	1-85937-158-2	£14.99	Oct
Leeds (pb)	1-85937-202-3	£9.99	Sep	Norfolk Living Memories	1-85937-217-1	£14.99	Oct
Ludlow (pb)	1-85937-176-0	£9.99	Sep	Preston (pb)	1-85937-212-0	£9.99	Oct
Norfolk (pb)	1-85937-195-7	£9.99	Sep	South Hams	1-85937-220-1	£14.99	Oct
Somerset	1-85937-153-1	£14.99	Sep	Suffolk	1-85937-221-x	£9.99	Oct
Tees Valley & Cleveland	1-85937-211-2	£14.99	Sep	Swansea (pb)	1-85937-167-1	£9.99	Oct
Thanet (pb)	1-85937-116-7	£9.99	Sep	Victorian and Edwardian Sussex			
Tiverton (pb)	1-85937-178-7	£9.99	Sep		1-85937-157-4	£14.99	Oct
Weymouth (pb)	1-85937-209-0	£9.99	Sep	West Yorkshire (pb)	1-85937-201-5	£9.99	Oct

See Frith books on the internet www.frithbook.co.uk

FRITH PRODUCTS & SERVICES

Francis Frith would doubtless be pleased to know that the pioneering publishing venture he started in 1860 still continues today. A hundred and forty years later, The Francis Frith Collection continues in the same innovative tradition and is now one of the foremost publishers of vintage photographs in the world. Some of the current activities include:

Interior Decoration

Today Frith's photographs can be seen framed and as giant wall murals in thousands of pubs, restaurants, hotels, banks, retail stores and other public buildings throughout the country. In every case they enhance the unique local atmosphere of the places they depict and provide reminders of gentler days in an increasingly busy and frenetic world.

Product Promotions

Frith products are used by many major companies to promote the sales of their own products or to reinforce their own history and heritage. Frith promotions have been used by Hovis bread, Courage beers, Scots Porage Oats, Colman's mustard, Cadbury's foods, Mellow Birds coffee, Dunhill pipe tobacco, Guinness, and Bulmer's Cider.

Genealogy and Family History

As the interest in family history and roots grows world-wide, more and more people are turning to Frith's photographs of Great Britain for images of the towns, villages and streets where their ancestors lived; and, of course, photographs of the churches and chapels where their ancestors were christened, married and buried are an essential part of every genealogy tree and family album.

Frith Products

All Frith photographs are available Framed or just as Mounted Prints and Posters (size 23 x 16 inches). These may be ordered from the address below. From time to time other products - Address Books, Calendars, Table Mats, etc - are available.

The Internet

Already twenty thousand Frith photographs can be viewed and purchased on the internet. By the end of the year 2000 some 60,000 Frith photographs will be available on the internet. The number of sites is constantly expanding, each focussing on different products and services from the Collection.
The main Frith sites are listed below.
www.francisfrith.co.uk
www.frithbook.co.uk

See the complete list of Frith Books at:
www.frithbook.co.uk
This web site is regularly updated with the latest list of publications from the Frith Book Company. If you wish to buy books relating to another part of the country that your local bookshop does not stock, you may purchase on-line.

For further information, trade, or author enquiries please contact us at the address below:
The Francis Frith Collection, Frith's Barn, Teffont, Salisbury, Wiltshire, England SP3 5QP.
Tel: +44 (0)1722 716 376 Fax: +44 (0)1722 716 881 Email: uksales@francisfrith.com

See Frith books on the internet www.frithbook.co.uk

TO RECEIVE YOUR FREE MOUNTED PRINT

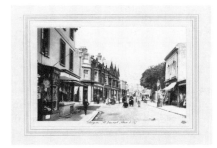

Mounted Print
Overall size 14 x 11 inches

Cut out this Voucher and return it with your remittance for £1.50 to cover postage and handling, to UK addresses. For overseas addresses please include £4.00 post and handling. Choose any photograph included in this book. Your SEPIA print will be A4 in size, and mounted in a cream mount with burgundy rule lines, overall size 14 x 11 inches.

Order additional Mounted Prints at HALF PRICE (only £7.49 each*)

If there are further pictures you would like to order, possibly as gifts for friends and family, purchase them at half price (no additional postage and handling required).

Have your Mounted Prints framed*

For an additional £14.95 per print you can have your chosen Mounted Print framed in an elegant polished wood and gilt moulding, overall size 16 x 13 inches (no additional postage and handling required).

*** IMPORTANT!**
These special prices are only available if ordered using the original voucher on this page (no copies permitted) and at the same time as your free Mounted Print, for delivery to the same address

Frith Collectors' Guild

From time to time we publish a magazine of news and stories about Frith photographs and further special offers of Frith products. If you would like 12 months FREE membership, please return this form.

Send completed forms to:
The Francis Frith Collection, Frith's Barn, Teffont, Salisbury, Wiltshire SP3 5QP

Voucher for **FREE** and Reduced Price Frith Prints

Picture no.	Page number	Qty	Mounted @ £7.49	Framed + £14.95	Total Cost
		1	**Free of charge***	£	£
			£7.49	£	£
			£7.49	£	£
			£7.49	£	£
			£7.49	£	£
			£7.49	£	£

Please allow 28 days for delivery	*** Post & handling**	**£1.50**
Book Title	**Total Order Cost**	**£**

Please do not photocopy this voucher. Only the original is valid, so please cut it out and return it to us.

I enclose a cheque / postal order for £
made payable to 'The Francis Frith Collection'
OR please debit my Mastercard / Visa / Switch / Amex card

Number .

Issue No (Switch only)Valid from (Amex/Switch)

Expires Signature .

Name Mr/Mrs/Ms .

Address .

. .

. .

. Postcode

Daytime Tel No . Valid to 31/12/02

The Francis Frith Collectors' Guild

Please enrol me as a member for 12 months free of charge.

Name Mr/Mrs/Ms .

Address .

. .

. .

. Postcode

Free Print - see overleaf